DESIGN IN COLOUR 1960s-80s

MEMPHIS

ANNE WATSON

ph^m powerhouse publishing
part of the Powerhouse Museum

First published 2002
Powerhouse Publishing, Sydney

Powerhouse Publishing
part of the Museum of Applied Arts and Sciences
PO Box K346 Haymarket NSW 1238 Australia
The Museum of Applied Arts and Sciences incorporates
the Powerhouse Museum and Sydney Observatory.
www.phm.gov.au

Editing: Jennifer Blunden
Design: Rhys Butler
Object photography: Marinco Kojdanovski
and Jean-Francois Lanzarone*
Picture research: Kathy Hackett*
Project management: Julie Donaldson*
Printing: Bloxham & Chambers, Sydney
* Powerhouse Museum

All objects are from the Powerhouse Museum collection
unless otherwise indicated.

National Library of Australia CIP
Watson, Anne
Powerhouse Museum
Mod to Memphis: design in colour 1960s-80s
Bibliography.
ISBN 1 86317 094 4
1. Powerhouse Museum - Exhibitions. 2. Furniture design -
History - Exhibitions. 3. Interior architecture - History -
Exhibitions. 4. Interior decoration - History - Exhibitions. I.
Watson, Anne (Anne Jeanette). II. Title.
749.249

Published in conjunction with the exhibition *Mod to
Memphis: design in colour 1960s–80s* at the Powerhouse
Museum, Sydney August 2002 — March 2003, curated by
Anne Watson.

Front cover: 'Globe' or 'Ball' chair by Eero Aarnio, Finland,
1965 (see p 34)

Back cover: 'Carlton' room divider by Ettore Sottsass,
Italy, 1981 (see p 69)

Contents and Designer Profile pages based on Florence
Broadhurst wallpapers (pp 60-63).

CONTENTS

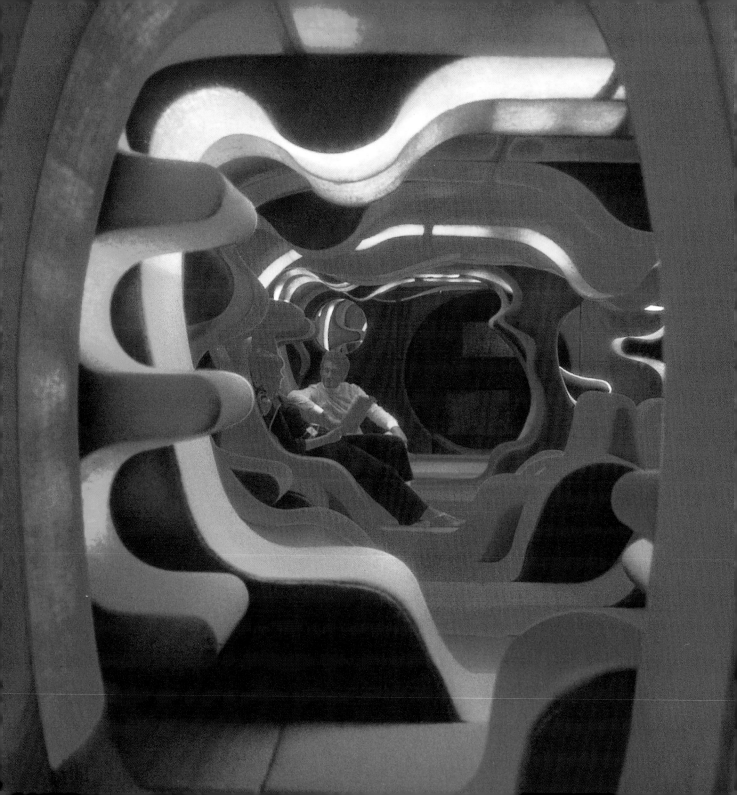

i TRODUCTiON

Looking back over a century of design from the vantage point of a new century, its defining features are falling into ever-sharper focus. Function and aesthetics, utility and appearance — the quest for a synthesis of these two seemingly irreconcilable ideals underpinned the complex evolution of styles and movements through the 20th century.

At one extreme, functionalism dictated the design of objects whose form and materials unambiguously and uncompromisingly reflected their structure and purpose. A central tenet of the modern movement's 'truth to materials' and 'form follows function' axioms, functionalism was a defining element of much 20th-century design prior to the 1960s. At the other extreme, 'decorativeness' — the use of colour, pattern, decoration and ornament for its own sake — created the potential for the kinds of stylistic excesses and idiosyncrasies that were an anathema to the functionalist agenda. While functionalism was a prescriptive program, rational and unemotional, 'decorativeness' was its reverse, without dogma, expressive and highly individualistic.

In reality neither extreme provided a satisfactory or lasting solution to the search for the 'right' design style. What gave 20th-century design its unique dynamic was the oscillation between the two extremes, the very contrariness of an era whose pace of technological and social change defied the enduring relevance of any one position.

Perhaps it is our greater ability to perceive and appreciate the richness of these pluralities and fluctuations that has refocused attention on the 1960s and early 1980s in recent years. One important designer whose career spanned this period was the Italian Ettore Sottsass. Something of a 20th-century design guru, Sottsass and his radical design philosophies contributed to the emergence of the 'anti-design' experimentation of the 60s and early 70s and to the formation of the Milan-based design collective known as Memphis in 1981. When asked how the qualities of good design persist in the face of technological change, he gave the revealing reply:

> *They don't endure at all because in my definition the qualities of good design are exactly the ones that don't endure but follow the changes of history … and … the changes of technology … In design what endures is man's curiosity towards existence and the drive to give metaphoric image to it.*[1]

In other words, there are no design absolutes; design reflects social, cultural and technological change, the complexities and contradictions of contemporary life. Yet what design of the 60s and 80s did have in common, apart from an unequivocal challenge to functionalism's entrenched notions of 'good design', was colour. Vibrant, unorthodox and liberated, colour became a rich and defining element in the vocabulary of the unique design language of the era.

Through the Powerhouse Museum's extensive 20th-century design collection, *Mod to Memphis* explores the role of colour, allied to form and material, in distinguishing the furniture, lighting, textiles and wallpaper designs that were the products of these creative and innovative years.

Verner Panton's 'Phantasy landscape' from his *Visiona 2* installation in conjunction with the Cologne Furniture Fair, 1970.

Bright pink, orange and poison green have replaced the pastel and earth tones once so popular in residential interiors … No longer timidly used … vivid colours are now in the forefront of modern design. Colour is being splashed extravagantly over end tables, armchairs and sofas. Bold eye–catching patterns and textures — brightly coloured furs and vinyls — cover ottomans, table tops and walls … We are on the threshold of a great new era, in which modern materials and technology will employ the oldest medium we know — colour — to create a new and far more beautiful environment.[2]

Above
Wallpaper samples from sample books used
by Florence Broadhurst, Sydney, Australia,
about 1967-73 (see p 60).

THE UNiNHiBiTED 60s

Mod, pop, swinging, space age … the 1960s was a decade of intense, reactive social and technological change. The aptly termed 'youthquake', the coming of age of the new consumer market of postwar baby boomers, demanded a fresh new 'look' to express the exuberance and idealism of a generation ready to challenge and reject existing values. Relative affluence, accelerated technological progress and ever-expanding modes of communication as the decade progressed resulted in more sophisticated and insatiable middle-income markets whose expectations and desires in many ways dictated design:

> *The role of design extended way beyond the need for harmony between form and function. The designer became a communicator, giving form to products, not in the abstract but rather within a culture, for a market place.*[3]

Importantly, design became a means by which this new generation of upwardly mobile consumers created its own identity, giving expression to changing lifestyles and values. Popular culture — design, fashion, music, film, art — was a defining phenomenon of the 60s. The mini skirt, the Beatles, the hard, 'commercial' edges of op and pop art, and the crazy, colourful swirls of psychedelia are iconic, if eclectic, identifiers of the rapid social and cultural shifts of this complex but exciting decade.

Advances in science and technology both fed and complicated these changes. The space race, culminating in the momentous moon walk of 1969, not only generated unparalleled scientific research and development programs, but inspired an outbreak of futuristic statements in everything from fashion to film to furniture. Space travel spoke of unimaginable possibilities, and design readily rose to the challenge of giving form to this fantasy future.

Plastic, until now with only limited design applications, quickly became the space-age material of choice, its perceived role in this imagined world giving it a new scientific and cultural legitimacy that brought it into the general ambit of design. The 60s was thus the decade when plastics technology came into its own, when plastics were increasingly recognised for the infinite range of aesthetic and functional possibilities they presented, rather than simply as cheap, disposable substitutes for more traditional materials. Poly-urethane foam, acrylics, fibreglass-reinforced polyester, ABS, PVC, laminates and synthetic fabrics offered the potential for a new generation of household products, particularly furniture, that could be coaxed into endlessly inventive shapes in a virtually unlimited range of vivid colours. Described as the 'teak of the 1960s'[4], plastic's potential to transform design was readily appreciated at the time:

> *If our permissive and youth–orientated society has produced a market ripe and ready for what it is about to get, the plastics industry has generated the technical impetus which has made it all possible. Although it seems only coincidence that the market has come to ripeness at the exact point when technical advance is making real impact, nearly all the curves and swoops of lounging furniture are dependent on the use of plastics in one of its many forms.*[5]

Fittingly, one of the chairs that pioneered the application of modern plastics technology to furniture production was designed at the very emergence of the decade. Verner Panton's injection-moulded plastic chair designed in 1960 was so far in advance of available technologies that it was seven years before it could be put into full production. Its one-piece, cantilevered form fulfilled all the requirements of mass production: it could be manufactured in a single process, and was lightweight, comfortable, stackable, elegant … and colourful. In a sense it provided a bridge between modernism's functionalist aesthetic and the 60s' desire for a more meaningful and expressive visual language — new shapes, new materials and new colours.

Similarly though differently, Vico Magistretti's 'Carimate' or '892' chair, designed in 1960 for the Carimate Golf Club near Milan, looked both forward and backward, its shiny red lacquer finish and chunky proportions giving new meaning to the traditional, country-style chair. Magistretti's designs for buildings, furniture and lighting from this period demonstrate his particular ability to work with manufacturers in utilising the latest technologies, an ability that quickly established his reputation as one of Italy's most important postwar designers.

By the mid 1960s the innovation and creativity that have since come to characterise the decade were in full swing. Plastics technology, the 'space race', changing lifestyles and a generation intent on forging its own identity created a volatile mix that resulted in many extraordinary design statements. As the decade drew to a close the emergence of the

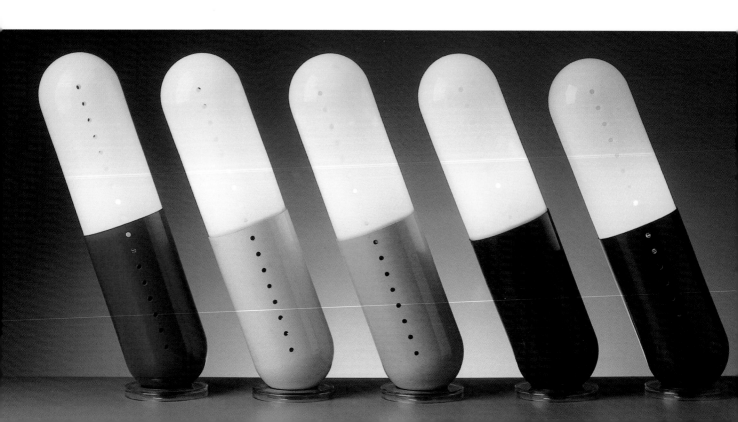

hippie counter-culture movement, youth's demonstration of its frustration over the slowness of social and political change, transformed the ebullience of the mid 60s to a mood of protest and upheaval. For a number of designers, particularly in Italy, design became a vehicle for expressing this unrest, this challenge to mainstream ideologies. The so-called 'anti-design' or 'radical design' of the late 60s and early 70s mirrored the prevailing non-conformist attitudes and presented the most radical challenge yet to modernism's rational good taste.

Chair design was particularly susceptible to the social and cultural vacillations of the decade and played an important role as a conduit for experimental technologies and new seating styles. Pierre Paulin's chairs for the Dutch furniture company Artifort, still in production today, contorted latex foam rubber covered in stretch wool into elegant, abstract forms. But it was the more widespread use of synthetic polyurethane foam from the mid 1960s that created unlimited opportunities for new seating shapes, sheathed in colourful stretch fabrics. Olivier Mourgue's 1963 'Djinn' series — used, famously, in Stanley Kubrick's classic 1968 film *2001: a space odyssey* — explored the possibilities of the new material moulded around a metal framework. And the aptly named 'Marilyn' of 1970 exploited the full potential of synthetic foam's mouldable properties. Fondly known as the 'lip lounge', this voluptuous, lip-shaped sofa, inspired by actress Marilyn Monroe, has endured as one of the more sensational pop icons of the era.

The new technologies and materials liberated chairs from the traditional ergonomic requirements of a seat, a back and four supporting elements. Finnish designer Eero Aarnio's hemi-spherical, plastic 'Pastilli', Gaetano Pesce's compressible foam 'UP' series and the revolutionary polystyrene-filled 'Sacco', endlessly reinterpreted as the 'beanbag', dispensed altogether with support elements. Instead they offered great potential for user 'self-expression', creating a host of informal lounging positions and the opportunity to completely redefine the look of interior spaces. Like Aarnio's iconic, space age 'Globe' chair of 1965, these were chairs with 'attitude' — and colour played a vital role in enhancing their novelty and appeal.

Lighting design was no less subject to the decade's search for a fresh aesthetic and made playful use of plastics and their unlimited range of brilliant colours. 'Pillola' *(left)*, designed in 1968 by Cesare Casati and Emanuele Ponzio, was not only multi-coloured, its illuminated, over-sized plastic capsules on weighted bases could be rearranged to form multiple configurations and angles. Similar 'interactivity' was also a feature of Superstudio's transparent pink acrylic 'Gherpe', whose curved sections, hinged at one point, could be repositioned according to the intensity of lighting required.

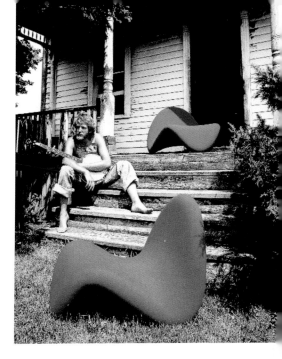

Above

The 'hippie' setting in this advertisement from about 1970 featuring the 'Tongue' chair by Pierre Paulin (France, 1967), dramatically emphasised the colourful sleekness of the chairs while simultaneously appealing to a young, unconventional market.

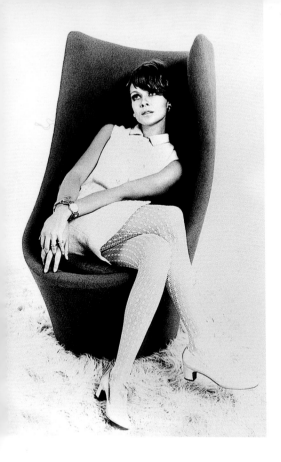

Above

Publicity image for Grant and Mary Featherston's 'Expo Mark II sound chair' 1967, adapted for the domestic market from their 'Expo talking chair' developed for the 1967 Montreal Expo.

Opposite

A typically creative and up-beat C&B Italia publicity image showing Gaetano Pesce's innovative 'UP1' and 'UP2' chairs, early 1970s.

The frequency of references to Italian designers and manufacturers in the history of 1960s design underscores Italy's role at the vanguard of design and manufacturing technologies in the postwar era. During the 60s Italy was quick to exploit the growing international consumer demand for stylishness and quality; its creative designers and marketing experts responded with a range of objects — furniture, lighting, cars — many of which are now regarded as design classics. Italy was the first country to fully realise the potential of plastics in the furniture industry and utilised the considerable skills of its experienced designers — Vico Magistretti, Marco Zanuso, Joe Colombo, to name just a few — to create sophisticated designs that allowed plastic to break free from its image as a cheap, substitute material. Italian ingenuity, design savvy, manufacturing vision and entrepreneurial flair helped foster an international climate where experimentation with new materials, forms and colours revolutionised the look of furniture and lighting.

Yet while European designers, particularly Italian, dominated the international scene in the 1960s, a number of creative Australian designers rose to the challenge of the demanding new market, despite the fact that this market was significantly smaller and local manufacturing industries were far less technologically advanced than in many European countries. For the 1967 Montreal Expo, itself a showcase of design innovation and technological achievement, Melbourne designers Grant and Mary Featherston created the sophisticated, colourfully upholstered 'Expo talking chair'. The Featherstons' experimentation with available technologies, such as in the 1971 fibreglass 'Poli' lounge and the 1974 spherical polyurethane foam 'Obo' chair, reflected their enthusiasm for meeting the challenges of adapting furniture design to mass-production techniques at a time when the local plastics industry was on the verge of expanding. In this context, the Sebel 'Integra' chair, the first Australian one-piece, injection-moulded polypropylene chair, developed in the early 1970s, represents an important milestone in Australia's furniture and manufacturing history.

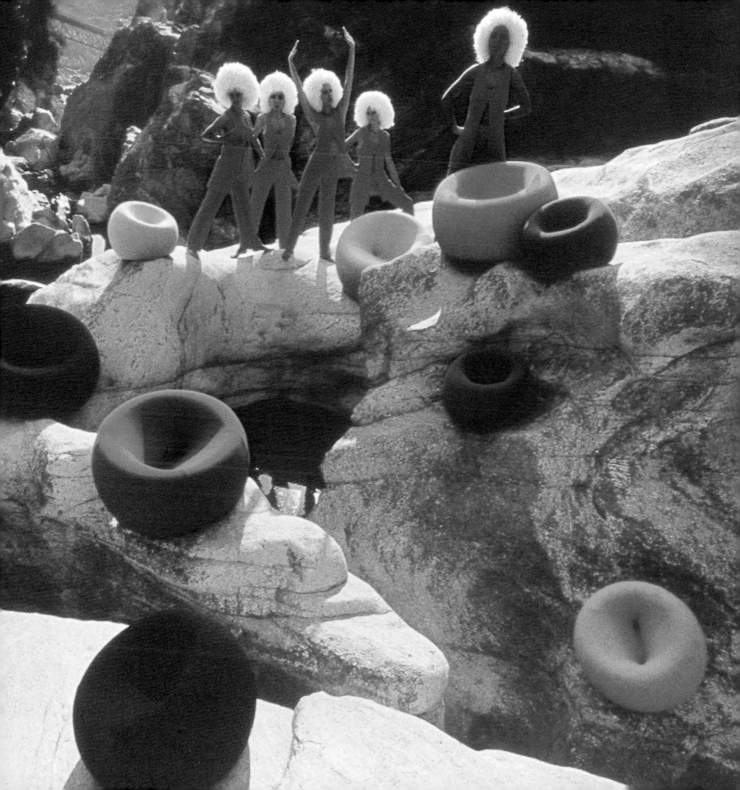

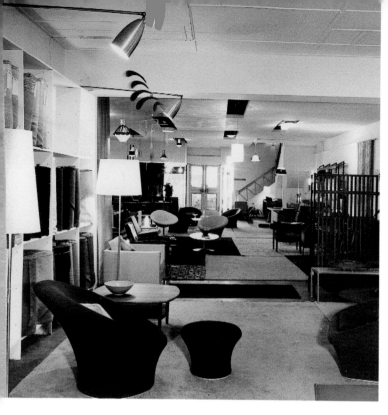

Above

The Artes Studios showroom, Sydney, late 1960s. Established in the late 1940s to retail locally designed furniture, Artes was a major importer of the latest European and American designs by the 1960s. Pierre Paulin's '560' chair and footstool, 1963, can be seen in the foreground.

Right

Mary Featherston in the 'Obo' chair, designed by her and Grant Featherston in 1974. A polyurethane and polystyrene sphere covered in colourful stretch fabric, the groovy 'Obo' was geared towards a 'cool' young market looking for chairs that suited the laid-back mood of the era.

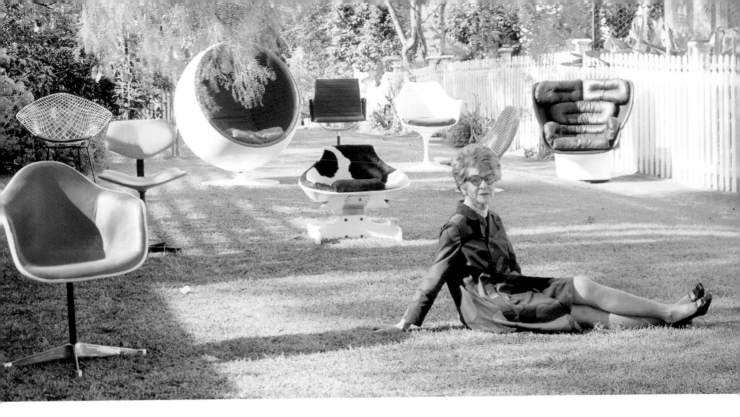

Throughout the 1960s and early 70s Australia depended largely on imported furniture and lighting to satisfy its more sophisticated, design-conscious market. The up-market Sydney furniture retailer Artes Studios, for example, imported Pierre Paulin's Artifort range from the mid 1960s and interior designer Marion Hall Best imported a number of the 'hippest' designs from Europe including Eero Aarnio's 'Globe' chair. It was this same clientele who had their interiors papered with Sydney designer Florence Broadhurst's flamboyant wallpapers and who sought out the bold Marimekko fabrics imported from Finland by Best and Russell Whitechurch of Sydney's Finnish Importing Company. Of all the vibrant, imaginative textiles designed in the decade from the early 1960s, those produced by Marimekko remain the most readily identified with the look and attitude of the 60s.

While the 60s was a decade of relative economic buoyancy, social optimism and uninhibited creativity, the worldwide economic recession of the mid 1970s saw a virtual reversal of this highly charged climate. Energy and materials shortages, unemployment and high inflation refocused design objectives towards the safer realms of functional rationalism. The oil crisis and the perceived need for greater environmental responsibility resulted in a re-evaluation of the expediency of plastics and a return to more traditional and durable natural materials — the restrained 'good taste' of the pre-60s era. As plastic fell into disfavour, exuberant colour, a defining element of 60s style, also fell victim to the conservatism engendered by the changed economic conditions.

Above
Australian interior designer Marion Hall Best in 1969 with some of the chairs she retailed. The photograph, in the garden of her Sydney home, includes Gordon Andrews' 'Rondo' and Eero Aarnio's 'Globe' chairs as well as designs by Saarinen, Eames, Bertoia and Colombo.

THE 1980S AND THE MEMPHIS PHENOMENON

In the endless cycle of action and reaction, the 1970s presented only a temporary 'glitch' in design's unerring capacity to reinvent itself. By 1980 a number of new designs heralding a turn-around in the prevailing conservatism of the previous decade had appeared on the market. Two examples of furniture, both, significantly, produced by the Italian company Cassina in that year, suggested a brighter future for the new decade. Gaetano Pesce's 'Sunset in New York' sofa, with its satiny red, semi-circular backrest, celebrated a deliberate return to the pop iconography of the 1960s and early 70s. Indeed, Pesce, one of Italy's most radical postwar designers, had never diverged far from the experimental, 'anti-design' philosophies that had inspired the creation of his extraordinarily innovative 'UP' seating series of 1969. Similarly Toshiyuki Kita's 'Wink', a chaise longue with an adjustable framework that allowed a number of different configurations, was developed in the late 1970s and shown to much acclaim at the Milan Furniture Fair in 1981. Its range of colourful, interchangeable loose covers again referred to the novelty and playfulness of much 60s furniture design.

However it was the Italian design group Memphis that was to most radically impact on the international design scene in the early 1980s. Formed in Milan in 1981, this design collaborative, led by Ettore Sottsass, picked up the thread of ideas that had lain dormant since the early 1970s and once more began to challenge conventional notions of ideal form and function. In contrast — indeed in opposition — to 20th-century modernism's fixation on function over decoration, form over style, Memphis provocatively embraced ornament, decoration and above all colour as a means to both reintroduce social meaning and to reconnect with the past. Colour, pattern, texture and often zany geometric shapes became trademarks of the Memphis post-modern style.

Memphis colour is comic strip colour ... plastic colour, hot dogs, sundaes, artificial raspberry syrup colour ... ridiculous colour, naïve colour, third world colour ... [6]

The need for design to both reflect and add meaning to contemporary culture was, for the Memphis group, once more on the design agenda. Consumerism, the unconventional, classical architecture, popular imagery, humour and the banal, all contributed to the unique Memphis design vocabulary:

> *It is concerned above all with breaking ground, extending the field of action, broadening awareness, shaking things up, discussing conditions, and setting up fresh opportunities.* [7]

Despite the rebellious tone of their agenda and the different backgrounds of the Memphis designers — Sottsass, Michele De Lucchi, George J Sowden, Nathalie du Pasquier, Marco Zanini, among others — Memphis products, including furniture, lighting, textiles and tableware, had a surprising unity. Barbara Radice, a writer and founding member of the collective, noted:

> *No one talked ... about 'how' to design. No one mentioned forms, colours, styles, decorations; as if by telepathy or celestial illumination, everyone knew exactly what to do, everyone knew that the others knew, or perhaps everyone pretended they knew.* [8]

Whether it was this consistent design language or just the sheer outrageousness of its loud, unconventional colours and bold, patterned surfaces, Memphis was an immediate hit from its first showing in September 1981. By the following year it was a worldwide phenomenon, brazenly gracing the pages of all the major design magazines. Memphis had arrived! Such was its impact that by the mid 1980s the influence of Memphis iconography had infiltrated the complete spectrum of domestic objects from the crafts (one-off, handmade objects) to mass-produced consumer goods. Tasmanian John Smith's 'Colourblock' table of 1984 was one of a number of examples of Memphis-inspired, post-modern furniture produced by Australian furniture makers and designers in the mid 1980s.

Ultimately it was the 'mainstreaming' of the Memphis style by consumer-driven manufacturers that spelt its demise. With the popularisation and debasement of its visual vocabulary, the very ideals that had inspired its creation — accessibility, innovation, experimentation — were, ironically, reversed. Despite this later dilution of its impact, Memphis succeeded in its objective to broaden design's appeal and played a decisive role in expanding the language of late 20th-century design. And without colour as a major element of this language, Memphis would have delivered a very different message.

INSPIRATION FOR A NEW CENTURY

It is a recognised phenomenon that turn-of-the-century societies tend to look backwards before moving forward and, indeed, the current popularity of 'things 60s' — fashion, design, music — would seem to bear this out. Iconic examples of 60s design are fetching increasingly high prices on the market and a number of chair designs, such as the 'Pastilli', the 'UP' and the 'Globe', have been reissued in recent years. And while some examples of 60s furniture, notably the 'Panton' chair, Pierre Paulin's elegant designs for Artifort and the ubiquitous beanbag, have never ceased production, they are now enjoying renewed popularity.

Many of the world's leading contemporary designers — Ron Arad, Marc Newson, Tom Dixon and Karim Rashid, to name just a few — reference the inspiration of the 60s in their work through their inventive use of colour and synthetic materials. At the 2002 Milan Furniture Fair, colour was a conspicuous component of the more innovative manufacturers' stands and several companies presented 'environments' that were in the experimental spirit of the late 60s. A number of exhibitions generated by European museums in the last few years, such as *Verner Panton* by the Vitra Design Museum, Germany and *Memphis remembered* by the Design Museum, London, have fuelled the popularity of 60s and 80s design.

Look around interior design and homewares stores and you will see Marimekko or Marimekko-like fabrics reappearing. Australian designer Florence Broadhurst's vibrant wallpaper designs are being reprinted, while paint companies are reintroducing the vivid, saturated interior colours so popular in the 60s. Even the oh-so-sixties shag-pile rug, a derivative of the early 1960s colourful Scandinavian long-pile *rya*, is back with a vengeance.

Is the current 60s fad nostalgia for the upbeat 60s lifestyle or the exuberance and idealism that defined it? Perhaps it is the outward manifestation of this exuberance in the liberated 60s sense of colour that is so beguiling today. Colour — playful, exultant, expressive — will continue to delight and engage for generations to come, albeit within the cyclical parameters of design, and the constantly changing predilections of the marketplace.

DESiGNER PROFiLES

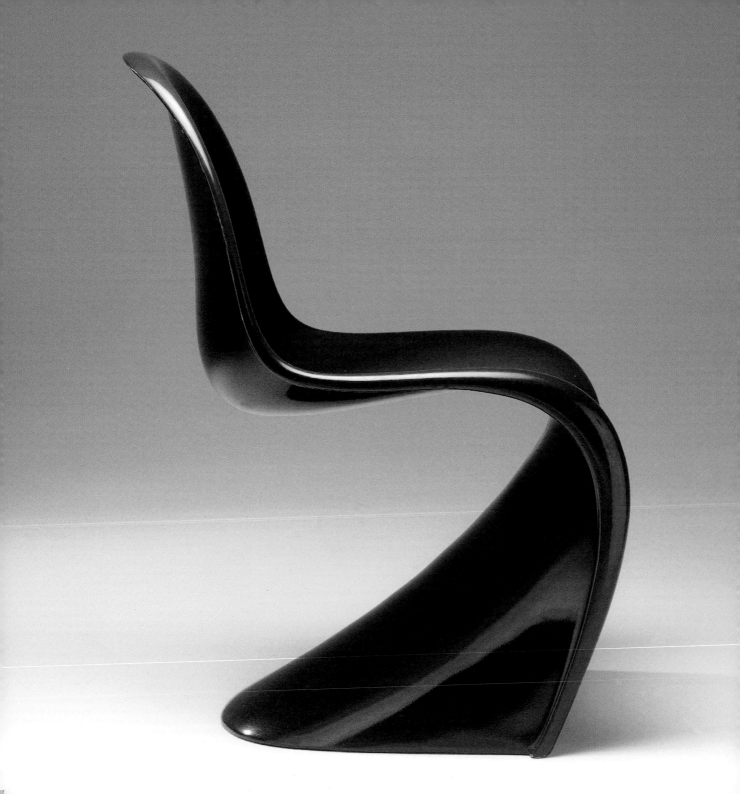

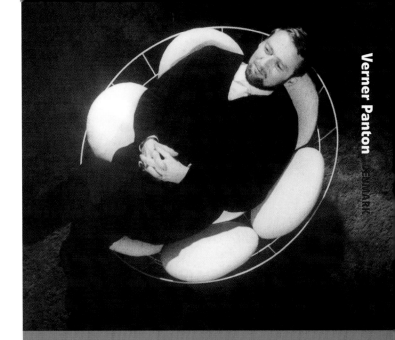

Verner Panton (born Gamtofte, Denmark, 1926; died Copenhagen, Denmark, 1998) has had a considerable impact on design in the second half of the 20th century. He studied architecture at the Royal Academy of Art, Copenhagen, from 1947 to 1951, and during these formative years was particularly influenced by the designers Poul Henningsen and Arne Jacobsen, in whose office he worked in the early 1950s. Given the significance of these early mentors, it is not surprising that Panton subsequently pursued a career as an industrial designer, preferring the challenge of new technologies to the handcraft traditions for which Denmark had developed an international reputation.

From his first notable design, the 'Cone' chair of 1958, Panton demonstrated what was to be his lifelong interest in experimentation, in the unconventional and in the emotional and cerebral impact of colour and geometric form. Although attentive to the demands of function, he was also preoccupied with stretching the boundaries of functionalism to embrace creativity, experiment and innovation. In this sense he provided a bridge between the practicality of the 1950s and the imaginative unorthodoxy of 60s design, whose bold aesthetic his own work anticipated by several years.

Along with the 'Cone' range (1958-60), his precocious designs included the acrylic 'Plexiglass' chair (1959), an inflatable plastic stool (about 1954) and above all the subsequently named

The main purpose of my work is to provoke people into using their imagination. Most people spend their lives housing [sic] in dreary, grey-beige conformity, mortally afraid of using colours. By experimenting with lighting, colours, textiles and furniture and utilizing the latest technologies, I try to show new ways, to encourage people to use their phantasy [sic] and make their surroundings more exciting.[9]

Above
Verner Panton in his 'Peacock' chair, 1961.

Opposite
'Panton' chair designed by Verner Panton, Denmark, 1960 and produced from 1967 in a number of plastics. This example is the second version made by Herman Miller/Vitra, Germany, 1968-70.
Polyurethane hard foam, 81 x 49 x 55 cm. 85/1976

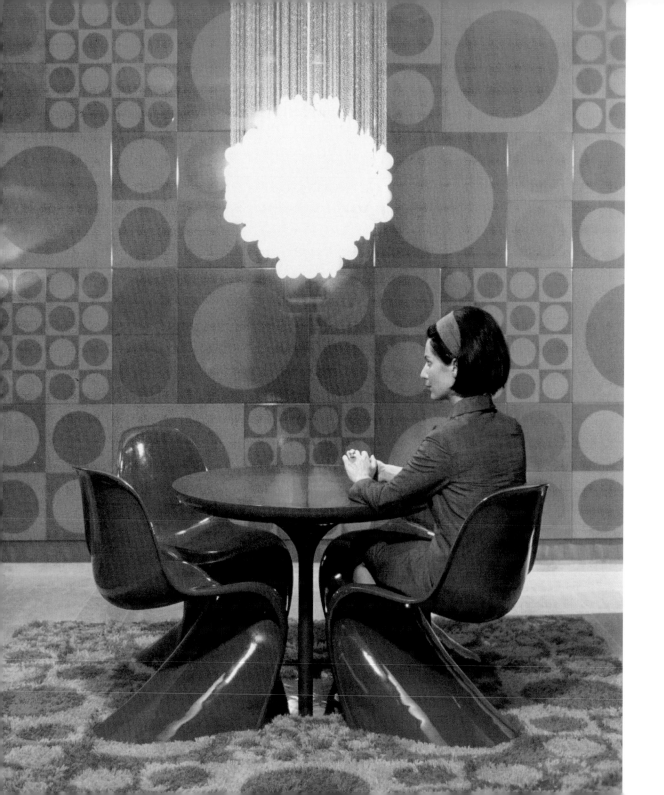

'Panton' chair. Conceived around 1960, this elegantly fluid design, to be manufactured in plastic in one continuous form, was not produced until 1967, when the furniture manufacturers Vitra and Herman Miller working with Panton developed suitable production methods. Using cold-pressed, fibreglass-reinforced polyester, this first run of chairs was made in a limited series of about 150. Panton's remarkable design had thus preceded the availability of suitable technologies by about seven years. In subsequent years, versions of the 'Panton' chair were manufactured using newly developed plastics technologies, most recently by Vitra in 1999 with injection-moulded polypropylene. The ongoing adaptation of new technologies to the production of the 'Panton' chair underscores its revered status as a timeless 20th-century design classic.

Throughout the 1960s Panton continued to design innovative seating furniture, lighting and textiles, but it was his interior design work of the 60s and 70s that provided him with the opportunity to pursue ideas concerning integrated living environments and the interplay of form, colour, lighting and materials. One of Panton's most spectacular and successful interior schemes was for the Astoria Hotel in Trondheim, Norway, in 1960. Its extraordinary dance bar, decorated from floor to ceiling with a repetitive circle motif and fitted with Panton's 'Topan' lights and 'Heart cone' chairs, anticipated the popularity of op art in the mid 1960s. A decade later Panton's 'Phantasy landscape' for the *Visiona 2* installation in conjunction with the Cologne Furniture Fair explored the idea of the interior as an integrated, sensory space, a kind of fantastic experience, to its extreme. In this vision of the future, bright colours, soft lighting and sexy, undulating forms made from synthetic foam — a development of Panton's radical 'Living tower' seating system of 1968 — created an artificial, womb-like cave, a veritable 'tunnel of love' that was more a sensory 'happening' than a habitable environment.

While Panton's most productive and creative years coincided with the unparalleled inventiveness of the 1960s and early 70s, in many ways he was always one step ahead of his contemporaries. His continuing experimentation with materials, particularly synthetics, with the expressive and physical qualities of colour and with the formal and decorative impact of geometric shapes has left a unique body of work whose contribution to 20th-century design is only now being fully appreciated. His career was the subject of a recent international travelling exhibition and accompanying monograph coordinated by the Vitra Design Museum, Germany.

Above
Verner Panton (with beard) with a prototype of the 'Panton' chair in the development department of Herman Miller/Vitra in Weil am Rhein, Germany, about 1966. Designed in 1960, the chair was first produced in fibreglass-reinforced polyester in 1967.

Opposite
Marianne Panton seated on a 'Panton' chair in a Panton-designed setting, about 1970. The light fitting is from Panton's 'Fun' series of lights made from linked shell discs.

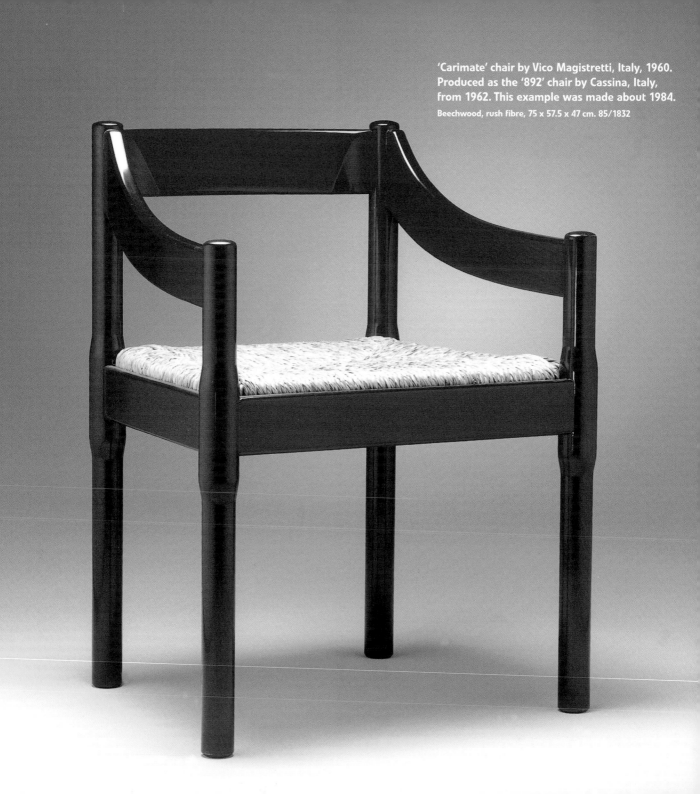

'Carimate' chair by Vico Magistretti, Italy, 1960.
Produced as the '892' chair by Cassina, Italy,
from 1962. This example was made about 1984.
Beechwood, rush fibre, 75 x 57.5 x 47 cm. 85/1832

Vico Magistretti in his Milan studio, mid 1960s. Shown are Magistretti's 'Eclisse' lamps and 'Demetrio' stackable tables, both designs the result of his collaboration with the innovative plastics manufacturer Artemide during the 1960s.

Like many mid 20th-century European designers, **Vico Magistretti** (born Italy 1920) trained as an architect. Graduating from the Milan Polytechnic in 1945, he joined his father's architectural office in Milan and through the 40s and 50s concentrated on architecture and town planning. He also designed a number of examples of simple wooden furniture that were highly acclaimed at the time. Magistretti was one of a generation of Italian designers influenced by the social and cultural ideas of architects such as Ernesto Rogers and Gio Ponti, and his career was to be defined by a versatility that embraced design for both mass and more limited markets in traditional as well as newly developed materials.

Magistretti's first major furniture design was the 'Carimate' chair for the clubhouse of the Carimate Golf Club, near Milan, in 1960. His reworking of the traditional rush-seated, wooden country chair was put into production as the '892' chair in 1962 by the innovative company Cassina, a leading Italian furniture manufacturer with whom Magistretti subsequently collaborated on several projects.

During the 1960s Magistretti's close collaboration with another progressive Italian company, Artemide, led to several important designs for plastic furniture and lighting, most notably the 'Eclisse' (eclipse) lamp of 1965 and the 'Selene' chair of 1969. This sleekly elegant, one-piece stacking chair, injection-moulded in a single process using ABS plastic, was to consolidate both Magistretti's international reputation and Italy's role as a leader in plastics technology. The 'Gaudi' and 'Vicario' armchairs of the following year used the same technology in a further elaboration of the revolutionary 'Selene'.

Despite the decline in plastics manufacturing as a result of world oil shortages in the mid 1970s and a more conservative international design climate, Magistretti's ability to adapt to new market demands is reflected in his leather-upholstered 'Maralunga' arm-chair and sofa of 1973 for Cassina. Its soft cushioning and distinctive yet much-copied adjustable arm and headrests set new standards for luxury seating.

In the more economically buoyant and aesthetically adventurous climate of the early 1980s Magistretti designed the colourful 'Sinbad' chair for Cassina, a work whose simplicity he found particularly satisfying:

> *I'm fond of it because it's a horse blanket, not an easy chair. I was supposed to be designing an armchair and this idea of the English horse blanket came into mind … it occurred to me that it was so beautiful that I'd like to add four buttons and sit down on it.*[10]

Throughout the 80s and 90s Magistretti continued to combine architecture practice with industrial design, collaborating with a number of Italian companies including Cassina, De Padova and Oluce. The continuing success of these partnerships throughout his career, owing as much to the flexibility of the Italian manufacturing industry as Magistretti's own creative versatility, epitomised the cooperative spirit between designer and manufacturer that under-pinned the international success of Italy's postwar furniture industries:

> *I like technology because it's what allows mass production … This is perhaps what differentiates my generation from the previous one … what I really like is teamwork, not with other architects, but with people in the manufacturing firm … Today's industrial culture deals with large, if not very large, numbers. Collaboration seems logical to me.*[11]

The recipient of many major design awards, Magistretti has also taught internationally including at the Royal College of Art, London, and the Domus Academy, Milan.

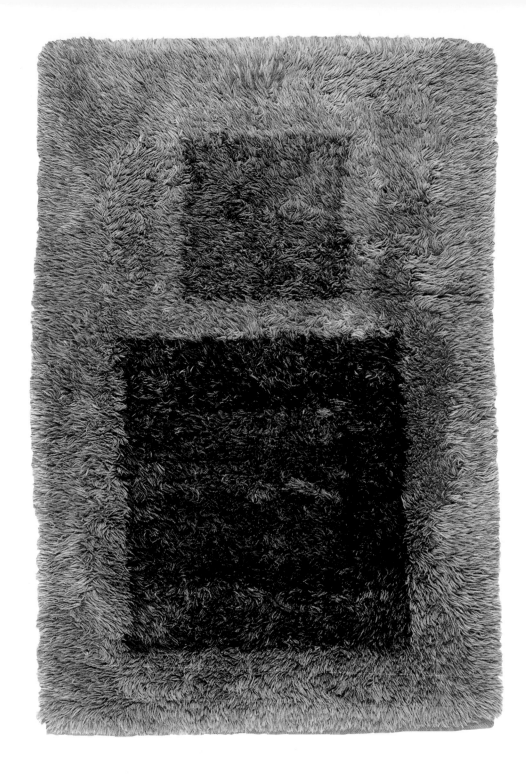

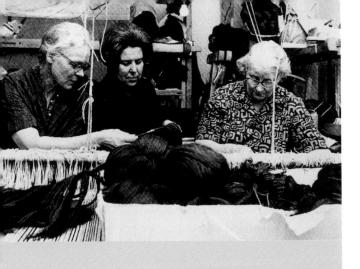

Textile artist **Uhra Simberg-Ehrström** (born Finland 1914; died Finland 1979) trained at the Helsinki College of Industrial Arts in the early 1930s. From 1935 she worked as a rug designer for the Helsinki-based Friends of Finnish Handicraft (FFH), a group founded in 1879 to promote Finnish textile art and traditional craft skills. During the early 20th century the FFH was active in initiating a revival in the appreciation and production of the *rya*, or *ryijy*, a hand-knotted, long-pile rug with strong connections to Finnish folk traditions. In the late 1930s a new type of *rya* became popular in Finland, with patterns based on contemporary rather than traditional designs. It was this style of modern art rug that inspired Simberg-Ehrström and during the 50s and 60s she excelled at producing her own unique interpretations of this traditional form. In 1967 she designed a remarkable, large-scale forest theme *rya* for the Montreal Expo.

Simberg-Ehrström was renowned for her compositional skills and her sense of colour. Many of her *rya* from this period use subtle colour gradations which, in combination with the textured long pile, give her geometric patterns a soft-focused, three-dimensional floating quality. Her 'Kaksi ruutua' (two squares) *rya* of the early 1960s with its asymmetrical, double-square pattern, has much in common with the colour-field paintings of American abstract artist Marc Rothko.

During the 1960s Finnish *rya* rugs and their derivatives (machine-made 'shag-pile' rugs and carpets) enjoyed international popularity, their colourful abstract designs and tactile 'woolliness' offering an attractive foil to the bare wooden floors fashionable at the time. And like the beanbag, the long-pile floor covering has since become a symbol of the 60s, its sensuous 'shagginess' suggestive of all manner of entertaining possibilities!

Above
Uhra Simberg-Ehrström (left) with Lisa Rosenberg and Ester Sandell in the workshop of the Friends of Finnish Handicraft. They are weaving the large-scale *rya*, 'Forest', for the 1967 Montreal Expo.

Opposite
'Kaksi ruutua' (two squares) *rya* (long-pile rug) by Uhra Simberg-Ehrström, Finland, early 1960s. Made by Suomen Käsityön Ystävät (Friends of Finnish Handicraft), Finland.
Acrylic, 188 x 128 cm. Courtesy Chee Soon & Fitzgerald, Sydney

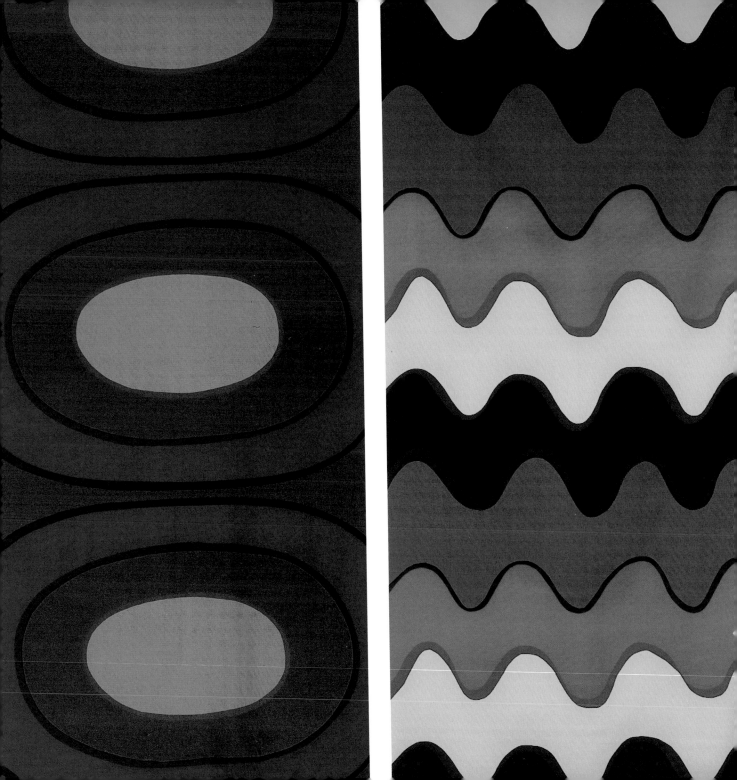

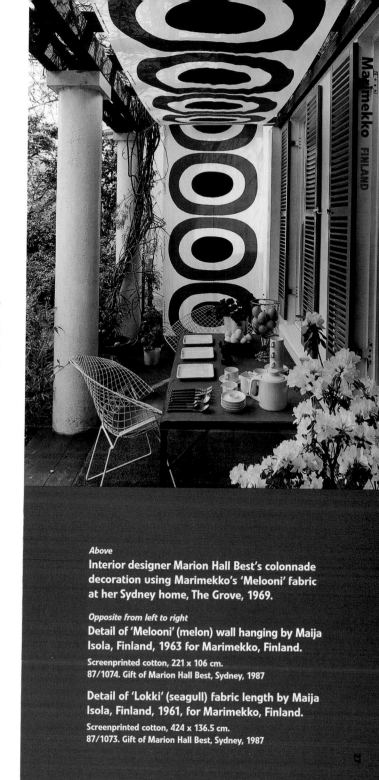

The Finnish textile company **Marimekko** has been one of the most conspicuous design success stories of the 20th century. Founded as a subsidiary of a company called Printex in Helsinki in 1949, Marimekko has flourished for over half a century, its success due largely to the dynamic personality and independent design philosophy of its founder Armi Ratia (1912-79).

Marimekko opened its first store in Helsinki in 1953, producing handprinted cotton fabrics and clothing, and began exporting in 1956. However it wasn't until the 1960s that the company's vivid, boldly patterned fabrics really began to capture the attention of world markets, ostensibly due to Jacqui Kennedy's much-publicised purchase of Marimekko dresses in 1958. By the mid 60s Marimekko had become the last word in modern interior decoration and liberated women's clothing.

As well as the entrepreneurial talents, unconventional strategies and personal energy of director Armi Ratia, much of Marimekko's early success can be credited to the creative skills of its first designers. Foremost among these was Maija Isola (born 1927), who joined the company at its founding in 1949. Trained as an artist rather than a textile designer, Isola's large-scale, abstract patterns in powerful colours — such as 'Lokki' (1961) and 'Melooni' (1963) — meshed perfectly with the geometric shapes and bright colours of the innovative furniture designed in Europe a few years later. While dramatic colour and pattern always played a major role in the Marimekko aesthetic, a range of influences, apart from the purely abstract, inspired its designs, from natural motifs to Finnish folk art to exotic cultures to contemporary art.

Above
Interior designer Marion Hall Best's colonnade decoration using Marimekko's 'Melooni' fabric at her Sydney home, The Grove, 1969.

Opposite from left to right
Detail of 'Melooni' (melon) wall hanging by Maija Isola, Finland, 1963 for Marimekko, Finland.
Screenprinted cotton, 221 x 106 cm.
87/1074. Gift of Marion Hall Best, Sydney, 1987

Detail of 'Lokki' (seagull) fabric length by Maija Isola, Finland, 1961, for Marimekko, Finland.
Screenprinted cotton, 424 x 136.5 cm.
87/1073. Gift of Marion Hall Best, Sydney, 1987

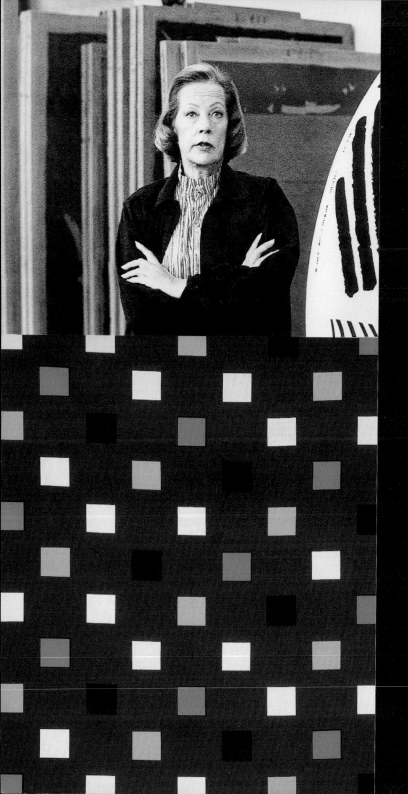

During the 1960s Marimekko fabrics were introduced to Sydney primarily through the efforts of Russell Whitechurch, a teacher, and interior designer Marion Hall Best. Whitechurch returned to Sydney from Scandinavia in 1957 with Marimekko textile samples, eventually establishing the Sydney agency for Marimekko through his Finnish Importing Company. Whitechurch's Suomi shops in Double Bay and Northbridge became a popular source of Finnish design throughout the 70s and 80s. Marion Best began retailing Marimekko fabrics through her Woollahra shop from the late 1950s. Surviving photographs of her shop and the many interior schemes she created reveal her enthusiasm for the bright, bold Marimekko look — a look that extended to her own choice of dress. Both Whitechurch and Best visited Armi Ratia at her home in Bökars, Finland, after attending the Montreal Expo in 1967.[12] The Powerhouse Museum has a selection of Marimekko textile lengths and samples from Best's studio and trade samples used by Russell Whitechurch.

Today, Marimekko's strong, bright fabrics are making a comeback with the re-release of several iconic 60s and 70s patterns by Maija Isola and Katsuji Wakisaka (born 1944) in the last few years. Marimekko's website describes Isola as having had the 'ability to see future trends' and calls her hundreds of designs 'an inexhaustible treasure trove'.[13] Clearly, like many of her designer contemporaries, Isola's special skills lay in her ability to create designs that both reflected — and transcended — the mood of the times.

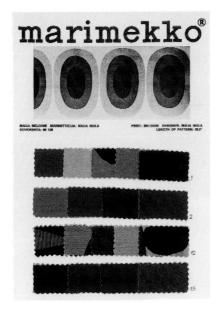
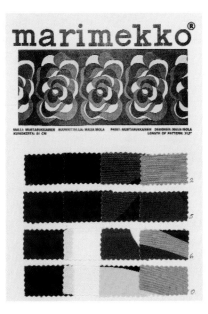
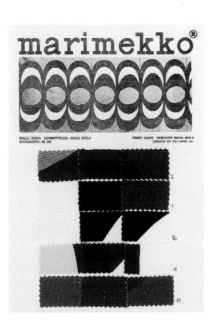

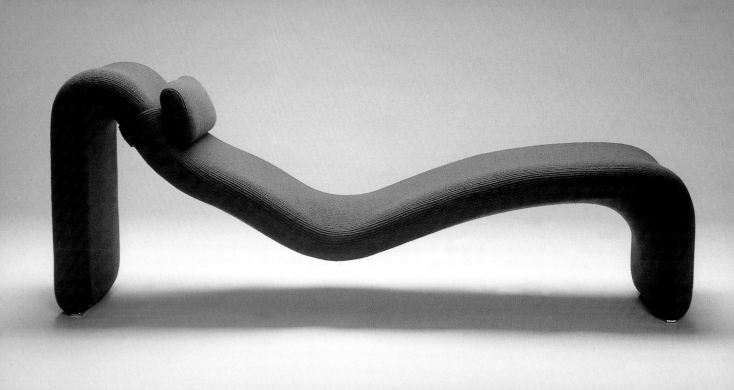

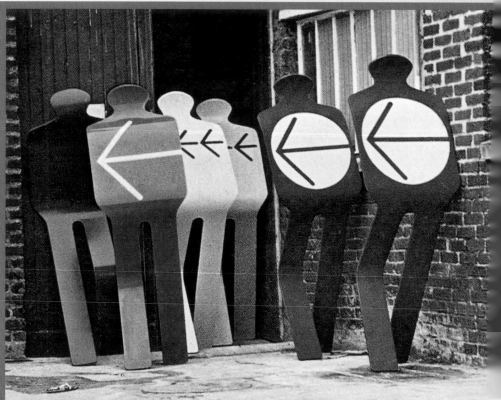

Above

'Djinn' chaise-longue by Olivier Mourgue, France, 1963. Made by Airborne, France.

Steel, polyurethane foam, nylon jersey fabric, 66 x 170 x 63 cm. 85/1451

Right

Olivier Mourgue's 'Bouloum' figures, which were used as circulation signage and seating in the French pavilion at the Osaka Expo 1970. This image appeared in the Italian design magazine Domus in June 1970.

While Italy and, to a lesser extent, Scandinavia were undoubtedly the centres of progressive design in the 1960s, France was also home to several designers whose innovative work challenged the prevailing status quo. Of these, Olivier Mourgue and Pierre Paulin made important contributions to the design landscape of the 60s with furniture whose distinctiveness is still widely acclaimed today.

Olivier Mourgue (born Paris 1939) trained as an interior designer from 1954-60 at the École Nationale Supérieure des Arts Décoratifs in Paris. He set up his own studio in Paris in 1960 and over the decade established consultancies with a number of French companies such as Airborne, Prisunic, Air France and Renault. It was Mourgue's work for Airborne, however, that was to deliver broad public recognition, most enduringly with his 'Djinn' (malevolent spirit) seating series from 1963. The 'Djinn' chaise longue's undulating, sculptural profile, achieved by wrapping polyurethane foam around a steel frame and covering it with stretch fabric, was almost immediately celebrated as a landmark of contemporary design, heralding a new future for the look of furniture. Indeed, so 'futuristic' did it seem at the time that 'Djinn' chairs and sofas, upholstered in bright red, were chosen to furnish the sterile white interior of the space Hilton in Stanley Kubrick's cult 1968 sci-fi film *2001: a space odyssey*.

If the organic lines of the 'Djinn' series gave the seating a vaguely anthropomorphic look, Mourgue's 'Bouloum' chair of 1968 made no bones about the inspiration for its quirky form. Named after a childhood friend, the 'Bouloum' was made of polyester moulded in the flattened, stylised shape of a 'Gumby'-like figure, then covered in stretch nylon fabric. At once eye-catching and somewhat disconcerting, 800 'Bouloum' figures were also used as signposts and seating in the French pavilion at Expo 70 in Osaka. Mourgue's interest in communicating whimsy and humour through design, accomplished so elegantly in 'Bouloum', led to a 'family of toy seats' in the 70s and 80s inspired by leaf, butterfly, kite and bird forms.

In his catalogue essay for the Philadelphia Museum of Art's *Design since 1945* exhibition in 1983 Mourgue wrote:

> *Beginning in the 1960s, I sought … to separate myself from the great family of designers. I have never felt at ease among them. Functionalism and rationalism cannot be the goal of design, an end in themselves; they are simply part of the honesty required for the construction of an object. I have the feeling that one must pursue other paths, and the condition of visual poetry interests me … Fantasy and memories can exist side by side with the object of high technology, and this is a good thing. Life is like that, full of chance, encounters, contradictions.*[14]

This highly individual interest in the inventive, in questioning the traditional boundaries of design, was reflected in other works of the late 60s including an all-white interior for his own apartment in Paris, a reclining surface enclosed in a revolving circular form, and a shag pile-covered communal seating unit variously described as a 'raft' or 'flying carpet' in 1967. Mourgue's avant-garde 'environments', so in tune with the experimental, 'alternative' mood of the late 60s, won him the prestigious commission to design the *Visiona 3* installation in Cologne for Bayer in 1971, a commission given the previous year to Danish designer Verner Panton.

As well as furniture and temporary and experimental interior environments, Mourgue designed interiors for Air France's Boeing 747s, consulted on interiors and colour schemes for Renault and continued to create new ideas for furniture throughout the 70s and 80s. In 1976 he moved from Paris to Brittany, where he taught at the École des Beaux Arts in Brest and has continued to design simple objects and paint watercolours.

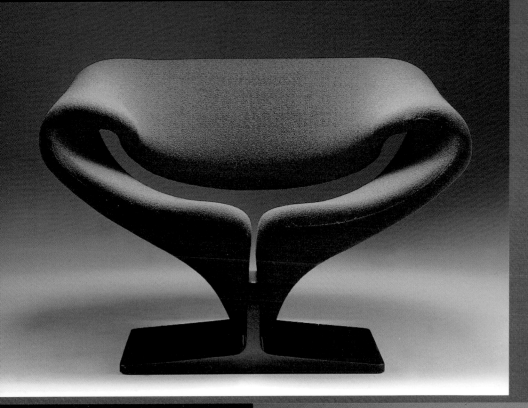

Left
'Ribbon' or '582' chair by Pierre Paulin,
France, 1966. Made by Artifort,
Netherlands. This example was made
about 1986.

Steel, foam rubber, wool jersey, wood,
72 x 100 x 80 cm. 87/1283

Opposite
Pierre Paulin's 'articulated carpet' of
1967 shown in *Domus* July 1968. As
well as designing for industry, Paulin
created avant-garde installations that
were very much in the innovative and
experimental spirit of the late 60s.

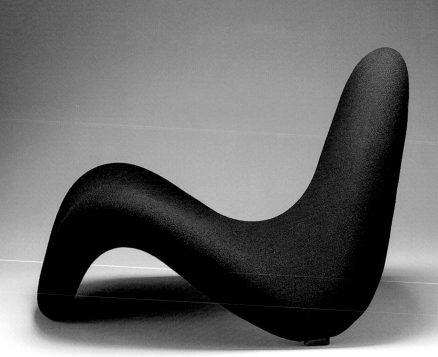

Right
'Tongue' or '577' chair by Pierre
Paulin, France, 1967. Made by
Artifort, Netherlands. This example
was made about 1986.

Steel, foam rubber, wool jersey,
64 x 86 x 95 cm. 87/1284

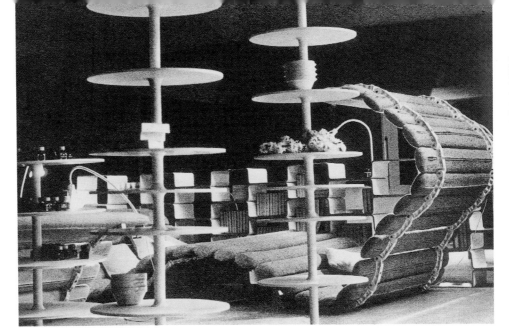

Like his compatriot Olivier Mourgue, **Pierre Paulin** (born Paris 1927) was one of a small wave of designers to emerge in France during the early 1960s. Paulin studied sculpture at the École Camondo, Paris, in the late 1940s and began designing furniture for Thonet in the early 50s. In 1958 he became the chief designer for the progressive Dutch furniture company Artifort, a collaboration that resulted in an extensive range of elegantly sculptural seating in the second half of the 60s.

Paulin's early designs for Artifort, such as the metal and leather '444' armchair, still referenced the functionalist rationale of modernism, but by 1966 his superb 'Ribbon' or '582' chair had established a completely new aesthetic that was to infect his work for the remainder of the decade. The 'Ribbon', so called because of its ingenious, curving, one-piece shape, was made from fabric-covered latex foam wrapped around a metal frame supported on a simple, pedestal-like base. Like Olivier Mourgue's contemporary 'Djinn' chaise longue, the 'Ribbon's pioneering shape was made possible by a mix of old and new technologies.

Other chairs for Artifort followed using a similar combination of materials. The wave-like 'Tongue' ('577') chair, with its undulating, stackable form, and the '300' easy chair, both 1967, contributed an important group of designs, several of which continue to be manufactured by Artifort today. Also for Artifort, and exploiting the sculptural possibilities of polyurethane foam to full effect, were a chubby, multi-coloured modular seating unit and the wavy 'ABCD' extendable lounge system of 1969.

In the late 1960s, and in the avant-garde spirit of these rebellious years, Paulin worked on a number of radical, non-commercial designs. One of these, 'Déclive', illustrated in *Domus* in July 1968 and described as an 'articulated carpet' or 'endless sofa', consisted of a series of upholstered slats with articulated joints that could be joined together to form a range of configurations. This canopied 'environment' echoed the installations created by a number of other designers at the time, notably Olivier Mourgue's and Verner Panton's schemes for the Visiona projects in Cologne.

Capable of designing for mainstream markets as well as smaller, avant-garde circles, Paulin has maintained a varied practice since he established his own industrial and interior design firm in the mid 1960s. Government commissions for Mobilier National have included seating for the French pavilion at Expo 70, Osaka, furniture and interiors for President Pompidou's private quarters at the Elysée palace and visitor seating for the Louvre. In addition to furniture, he has designed car interiors for Citroën, telephones for Ericsson and packaging for Christian Dior. The recipient of numerous awards, Paulin was the subject of a retrospective exhibition at the Musée des Arts Décoratifs, Paris, in 1983.

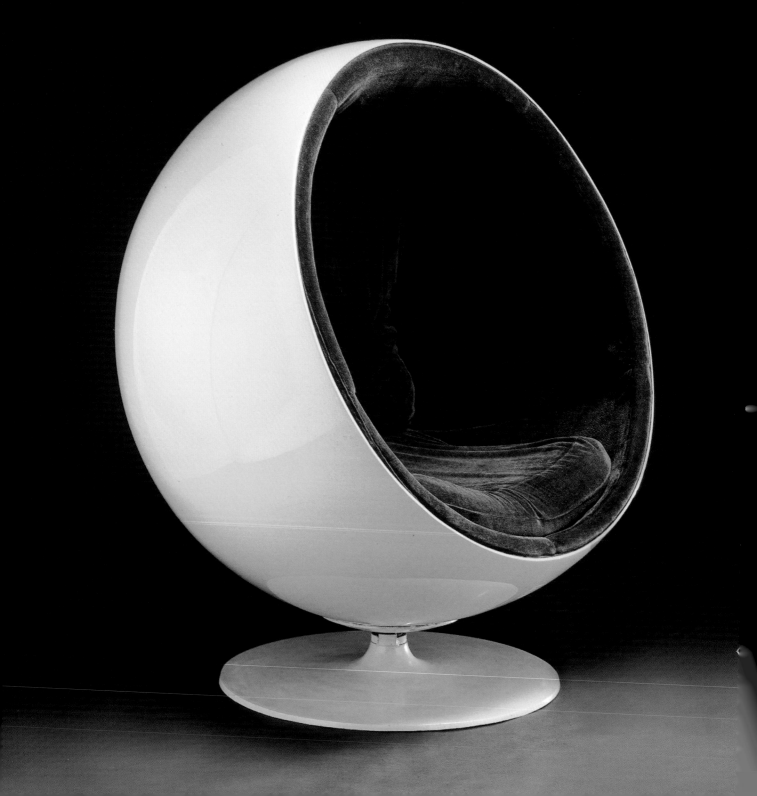

Eero Aarnio (born Finland 1932) trained as an interior and industrial designer at the Helsinki Institute of Industrial Arts in 1954-57 and established his own office in 1962. While his earliest furniture designs used traditional materials like rattan (albeit in a 1950s modernist idiom), by the mid 1960s his pioneering work as a designer of plastic furniture was well underway. The 1965 'Globe' chair and the 1968 'Pastilli', both manufactured by the progressive Finnish company Asko in bright, shiny fibreglass-reinforced polyester, were to become icons of 60s style and quickly established Aarnio's international reputation.

Like Verner Panton in Denmark, Aarnio's fascination with the possibilities of synthetic materials and abstract geometric shapes challenged the very basis of Scandinavian design, with its strong craft traditions, emphasis on natural materials and its inspiration drawn from nature. Only Finnish designer Eero Saarinen, whose pedestal-based 'Tulip' chair of 1956 may have provided the inspiration for the pedestal support on Aarnio's 'Globe', had diverted the direction of Finnish design to such an extent. But while Saarinen's chair has an elegant timelessness about it, Aarnio's moon-like 'Globe', with its capacious, upholstered interior and optional stereo speakers, was unmistakably 'of its time', inviting associations with a sci-fi future and suggesting levels of repose and escape that held particular appeal for a young, hip generation.

So readily was the 'Globe' identified with the 'look' and mood of the 60s that it was used in settings as varied as fashion designer Mary Quant's London boutique (1967), in the cult TV series *The prisoner* (from 1967) and in the film *The Italian job* with Michael Cain (1968). In Sydney, interior designer Marion Hall Best imported examples of the 'Globe' chair, using one in her pink and orange 'Room for Mary Quant' setting in 1967.

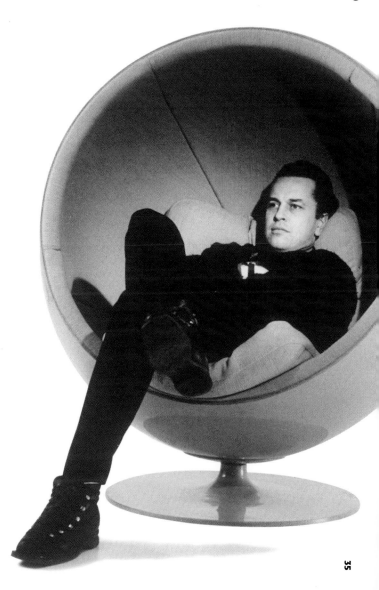

Right
Eero Aarnio in his 'Globe' chair at the Cologne Furniture Fair, 1966.

Opposite
'Globe' or 'Ball' chair by Eero Aarnio, Finland, 1965. Made by Asko Finnternational, Finland.

Fibreglass-reinforced polyester, foam rubber, velveteen, aluminium, 122 x 100 cm. 85/1975

Aarnio's other designs of this period — the 1965 'Kantarelli' (mushroom) table, the clear plastic, suspended 'Bubble' chair and hemispherical 'Pastilli', both 1968, and the 1971 globular 'Tomato' — continued his exploration of the limitless potential of plastics to create new shapes that bespoke the mood of an era. Over three decades later these remarkable designs still look 'futuristic'— so much so that the German company Adelta has re-issued nine of Aarnio's designs (including the 'Globe', 'Pastilli', 'Bubble' and 'Tomato') in recent years. Yet ironically, despite the 'techno-futuristic' look of his 60s work, Aarnio freely acknowledged in 1970 that nature was his starting point:

> *The shape of an egg is nature's strongest geometrical form … It also turns out to be one of the most comfortable forms to hold up the human body.*[15]

Aarnio's creative association with the innovative Finnish manufacturer Asko in the 1960s resulted in his most daring designs but he also designed furniture for the Italian firm Cassina at this time, albeit for a slightly more conservative market. During the 1970s Aarnio returned to more traditional materials, designing his wooden 'Viking' dining table and chairs for Polardesign in 1982. However, Aarnio's period of greatest recognition was during the 60s, when his innovative furniture designs contributed to numerous competitions and exhibitions such as the 1968 *Contemporary chairs* at the Musée des Arts Décoratifs, Paris, and in 1970 the landmark exhibition *Modern chairs 1918-1970* at the Whitechapel Gallery, London.

Above
Aarnio in his 'Pastilli' chair about 1968.

Opposite
'Pastilli' or 'Gyro' chair by Eero Aarnio, Finland, 1968. Made by Asko, Finland.
Fibreglass-reinforced polyester, 50 x 96 x 96 cm. 85/1974

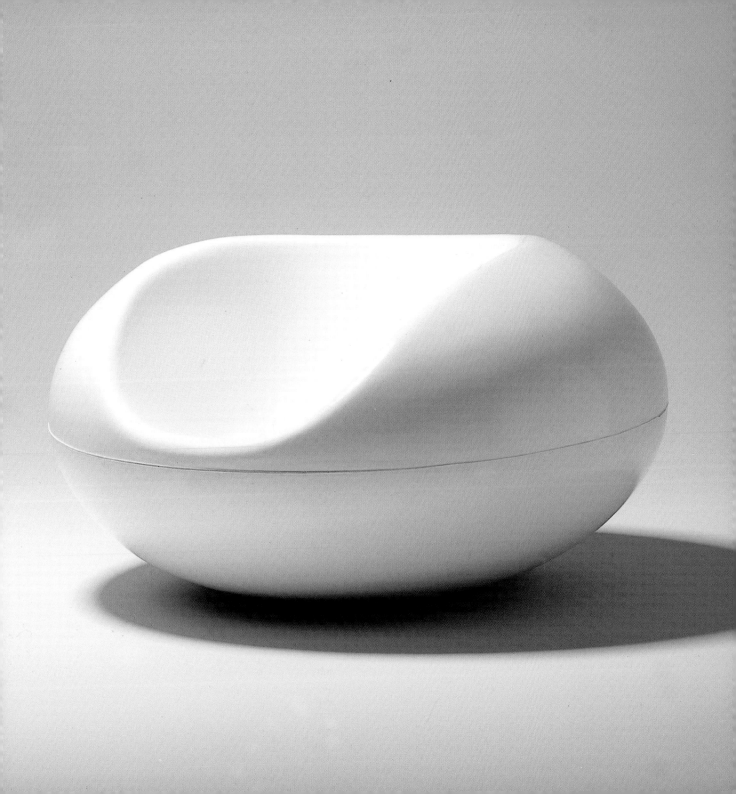

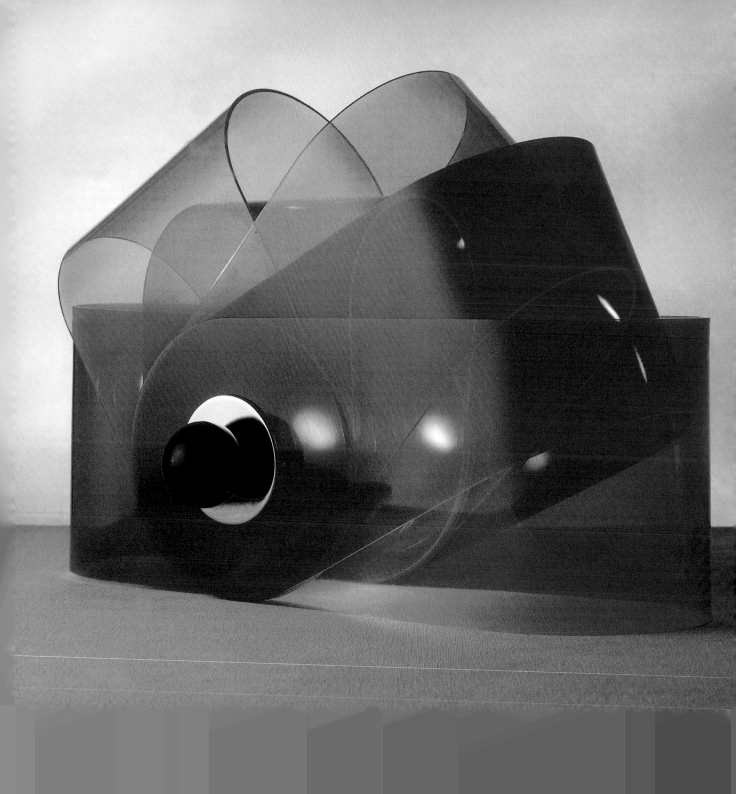

The architectural and design collective **Superstudio** was established in Florence in 1966 by Adolfo Natalini and Cristiano Toralda di Francia, and was joined in the early 70s by Gian Pietro Frassinelli, Alessandro and Roberto Magris and Alessandro Poli. Together with another avant-garde architectural group, Archizoom, Superstudio's radical agenda challenged mainstream social and political orthodoxies and questioned the very purpose and foundations of design. Their 'anti-design' vision — a manifestation of the widespread political unrest in the late 60s and early 70s — prompted a series of real and conceptual architecture, design and film projects proposing a utopian future that rejected existing ideologies. One concept for the imposition of a global grid-like system that 'neutralised' the environment — the 'Continuous monument' series of 1969 — resulted in the highly minimal 'Quaderni' series of tables covered with a grid pattern on white plastic laminate and produced by Zanotta in 1971.

Superstudio's work and philosophy was the subject of a lengthy article in *Domus* (June 1969) in which the group expounded with manifesto-like zeal its vision for an improved world:

If, then, the problem is one of living creatively and finding the true answers to our problems, of avoiding the prefabricated answers imposed by the great monopolies of truth (the pitfalls of the affluent society) we then come to propose 'invention design' as an alternative or variant to 'product design' or 'industrial design' … Our problem is to go on producing objects big brightly-coloured cumbersome useful and full of surprises, to live with them and play with them together and always find ourselves tripping over them … but it will not be possible in any way to ignore them. They will exorcise our indifference.[16]

Despite Superstudio's somewhat subversive and critical position, many of the objects it and other 'counter-design' groups created look engagingly fresh and exuberant today. Superstudio's 'Gherpe' table lamp is a case in point. Made by Poltronova from curved pink acrylic units pivoting, cabriolet-style, on a fixed point, it looks benign enough, even comical. However, a drawing for the lamp inscribed, 'If you don't behave the gherpe [monster] will get you'[17] suggests the probability of a terse political message disguised in its toy-like appearance. Although when designed in 1967 'Gherpe' may have been intended as both a snub at the 'good taste' of modernism and the apparently conservative social values that sustained it, the creativity at play in its very 'alternativeness' has produced a delightful, functioning object that is an essay in imaginative design.

Opposite
'Gherpe' table light, Superstudio, Italy, 1967. Made by Poltronova, Italy, 1967-72.

Acrylic, metal, glass, 40 x 52 x 20 cm. 88/1055

Right
Superstudio, drawing for the 'Gherpe' lamp, Italy, 24 November 1967. The annotation translates as 'If you don't behave the gherpe [monster] will get you.'

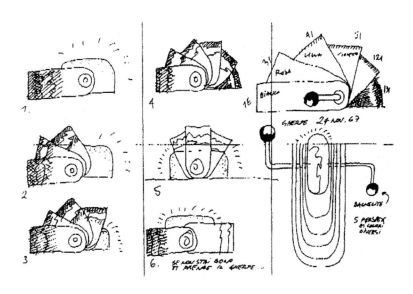

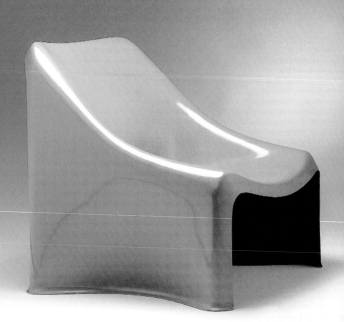

The early career of **Grant Featherston** (born Geelong, Victoria, Australia, 1922; died Melbourne, Australia, 1995) as a furniture designer coincided with a period of growth and optimism in postwar Australia. With an enthusiasm for making things since childhood and largely self-taught as a designer, Featherston designed his first chair in 1947, the canvas-webbed 'Relaxation' chair. Although derivative of European and American styles, the chair was hailed by Melbourne architect Robin Boyd for its modernity and set standards in function, style and quality to which Featherston adhered unwaveringly over the next three decades.

In the early 1950s Featherston developed the now justly famous 'Contour' range of chairs. Launched in 1951, the 'Contour' was an immediate success and was subsequently developed in a range of styles and seating types with different upholstery finishes. Its innovative plywood shell was formed using a process that Featherston developed himself in the absence of suitable plywood-moulding technology locally. Much copied, the 'Contour' chair became synonymous with stylish, informal living in postwar Australia and established Featherston's reputation as a leading Australian furniture designer.

In 1957 Featherston was appointed consultant designer to Aristoc Industries, a Melbourne manufacturer of metal furniture. This highly fruitful collaboration resulted in the production of a variety of chairs for a diverse range of purposes until 1970, including the 'Mitzi' (1957), 'Scape' (1960) and the 'Expo 67 talking chair'. While most of the Aristoc chairs were geared toward the general domestic or commercial market, the 'Expo 67' chair was specifically commissioned (by Robin Boyd) for the Australian pavilion at the Montreal Expo. As well as being lightweight, durable, comfortable and smart, the chair needed to incorporate an audio system that provided programs in English and French on various aspects of Australian life. Using the latest plastics technology — a rigid polystyrene shell covered in polyurethane foam — the 'Expo 67' chair was adapted for the domestic market as the 'Expo mark II sound chair'. Covered in bright wool fabric and marketed with the help of leggy, mini-skirted models, it was the epitome of 60s chic.

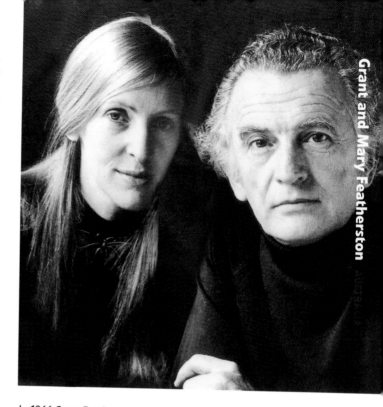

Grant and Mary Featherston

In 1966 Grant Featherston had formed a partnership with his wife **Mary Featherston** (nee Currey, born England 1943), an interior designer who had studied at the Royal Melbourne Institute of Technology (RMIT) in the early 1960s. Their 'Expo 67' was only the beginning of a run of chairs that, in the spirit of the times, explored the almost limitless possibilities of plastics in the creation of innovative seating forms. For the Featherstons the:

> ... *integral one-piece plastic chair [represented] ... the pinnacle of the furniture designer's aspirations. Plastics and moulding technology express the synergetic challenge most eloquently. No other material so inherently speaks of body and process, offering a 'negative' of the human body.*[18]

The rotation-moulded polyethylene 'Stem' chair (1969), the shiny, one-piece fibreglass 'Poli' chair (1971) and the 'ultra hip' spherical polystyrene and polyurethane foam 'Obo' (1974) helped expand the technological capabilities of local furniture manufacturers at a time when their viability was constantly under threat from foreign imports. The Featherstons' efforts to keep the local industry competitive while supplying the market with chairs that were technologically and stylistically equal to overseas examples resulted in an important body of work that has significantly enriched Australia's design history.

Marion Hall Best (nee Burkitt, born Dubbo, New South Wales, Australia, 1905; died Sydney 1988) was one of Australia's most important and influential 20th-century interior designers. At a time when there was no formal training in interior design, Best's career developed in the 1920s and 30s from the contacts she made in Sydney's art and design circles and from her own personal interests, particularly her passion for colour. Attending Thea Procter's Sydney painting classes in the late 20s, Best remarked:

I knew I wanted to work in big areas of colour in a three-dimensional way which belonged to living spaces …[19]

During the 1930s several decorating commissions and more formalised training laid the foundations for an interior design career that was to span four decades.

In 1938 Best opened Marion Best Pty Ltd, a workroom and display area in the Sydney suburb of Woollahra, to which she later added a retail business. Until its closure in 1974, the shop was to stock local designs — furniture by Gordon Andrews, Clement Meadmore and Roger McLay, and printed fabrics by Frances Burke, Douglas Annand and others — as well as a wide range of imports. During the 1950s and 60s Best's business became an important source of contemporary international products for the local design profession, supplying the latest fabrics by Marimekko and Jim Thompson and innovative furniture by Saarinen, Noguchi, Bertoia and Aarnio. In 1949 she also opened a small shop in Sydney's Rowe Street, an enclave of shops and galleries specialising in art, craft and design.

At the peak of her career in the 1960s, Best designed many notable interiors for corporate and private clients in Sydney as well as several exhibition settings. Apart from her pioneering promotion of contemporary design through her shops and her own work, Best was renowned for her use of colour in interior schemes, particularly the colour-saturated glazed finishes she developed.

Colour took wings in the 1950s. We were always experimental but not irresponsible. Risks were always calculated. It was the glazing technique that made the colours sing with such freedom.[20]

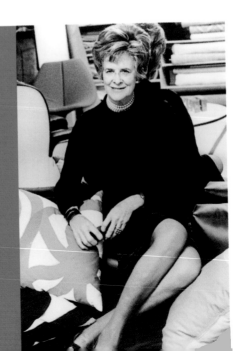

Right
Marion Hall Best in her Sydney shop, 1969.
Best's business was an important local source of the latest European and American fabrics, furniture and lighting including Marimekko printed cottons and chairs by Saarinen, Aarnio and Noguchi. Visible in the background is Gordon Andrews' 'Rondo' chair, retailed by Best from 1956.

Opposite
Marion Hall Best's 'A room for Mary Quant', 1967. Inspired by the young, hip style of fashion designer Mary Quant, this exhibition setting included Eero Aarnio's 'Globe' chair and a pink, long-pile wool *rya*.

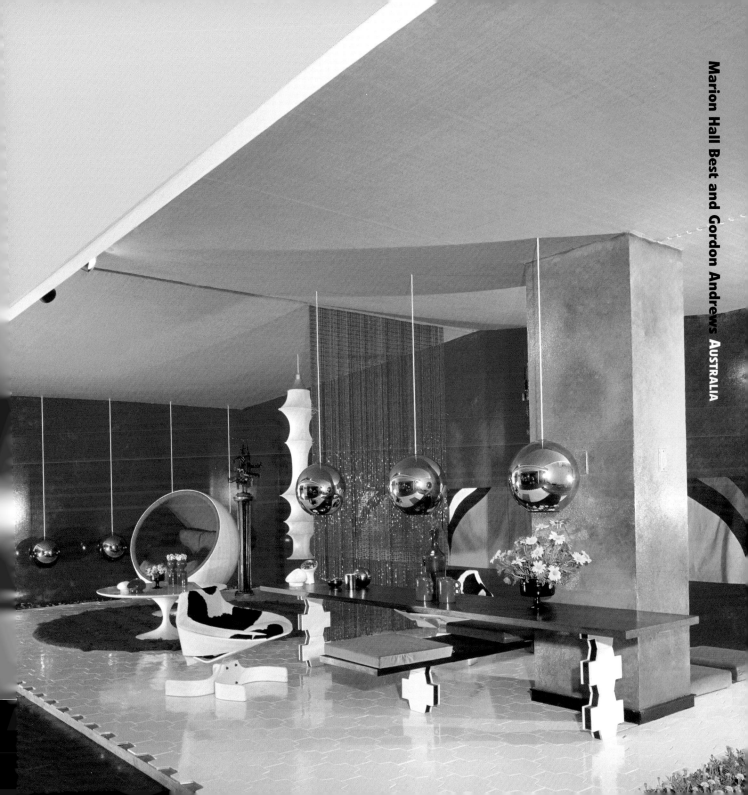

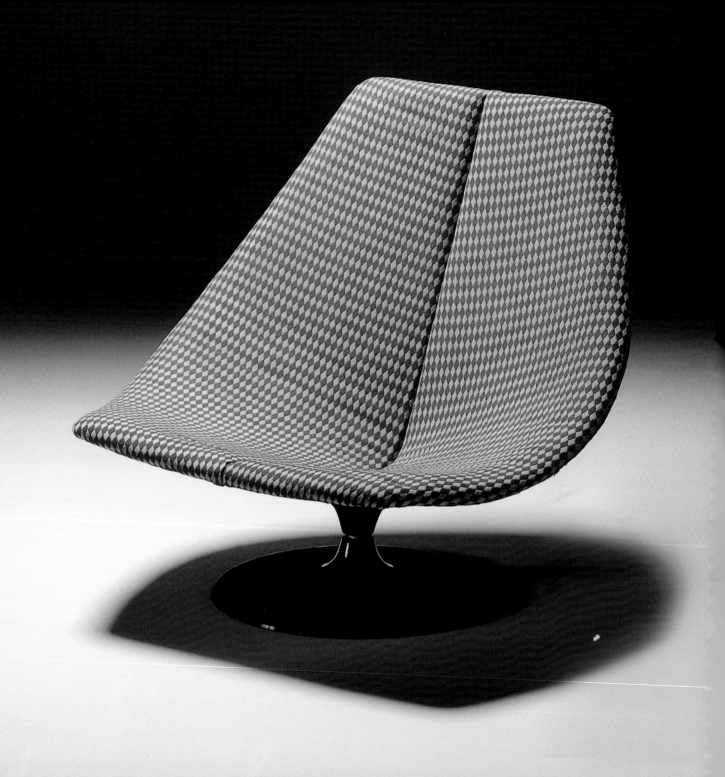

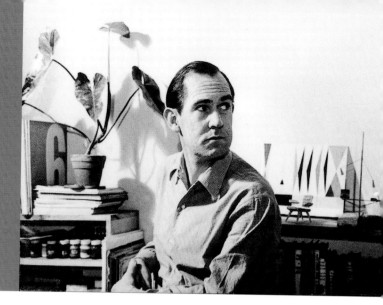

Gordon Andrews' (born Sydney 1914; died Sydney 2001) long career as a graphic and industrial designer developed out of a passion for making things and his art studies at East Sydney Technical College. A contemporary and friend of Marion Hall Best, he worked during the 1930s as a commercial artist for advertising agencies in Sydney and London, visiting the Paris and New York world fairs in 1937 and 1939. After returning to Sydney, he worked for the De Havilland aircraft company during the war, as did Marion Hall Best. Andrews' and Best's career paths crossed again in the late 1940s when both worked for the Sydney department store David Jones, Andrews as a consultant designer and Best as director of the store's progressive art gallery. Needless to say Andrews designed a number of the gallery's exhibition catalogues at this time.

In London with his family by 1950, Andrews worked for the Design Research Unit on Festival of Britain projects and began an important association with Olivetti that resulted in the design of a number of the company's showrooms in England in the early 1950s and in Sydney in 1956. For Olivetti's London showroom Andrews developed the 'Gazelle' chair, while his 'Rondo' chair was first used in the Sydney showroom. Both chairs were produced, with some modifications, throughout the late 50s and 60s. As well as graphic, interior and furniture design, Andrews' versatility extended to lighting, cookware, jewellery, sculpture, trade and cultural exhibitions and, most significantly, Australia's first decimal currency notes released in 1966.

With their common enthusiasm for innovative design at a time when Australia's design profession was small and generally conservative, it is not surprising that Marion Hall Best's and Gordon Andrews' careers shared many parallels and meeting points. Both travelled overseas extensively (running in to each other at the 1954 Milan Triennale), gaining much from exposure to design in Europe and America and benefiting long-term from contacts made there. Both worked for David Jones in the late 1940s and, according to Andrews, it was Best who placed the first order for his furniture in Sydney in the mid 1950s: 'Her encouragement and enthusiasm for my furniture provided a regular outlet for this side of my design efforts, particularly my Rondo and Gazelle chairs.'[21]

As well as retailing his furniture and using it in her own interiors, Best collaborated with Andrews on the redesign of her Woollahra shop in 1956 and on the exhibition setting 'Breakfast with Gordon Andrews' at David Jones in 1962. Surviving photographs of this stunningly modern setting, which was fitted with Andrews' rug, photographic mural, perspex mobile, table and colourfully upholstered chairs, are a testament to the creative skills and innovative aesthetic of these two inspirational and pioneering Australian designers.

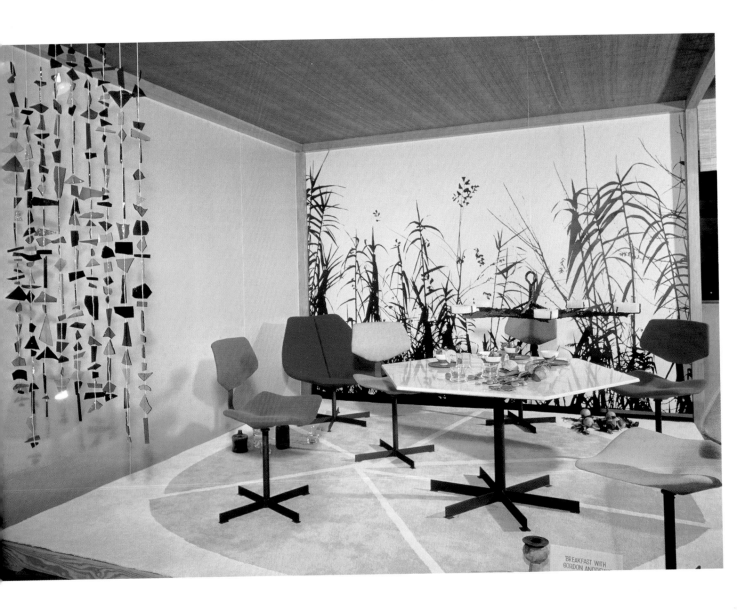

'Breakfast with Gordon Andrews', Marion Hall
Best, 1962, David Jones department store,
Sydney. Best designed this setting using
furniture and decorative features by Andrews.

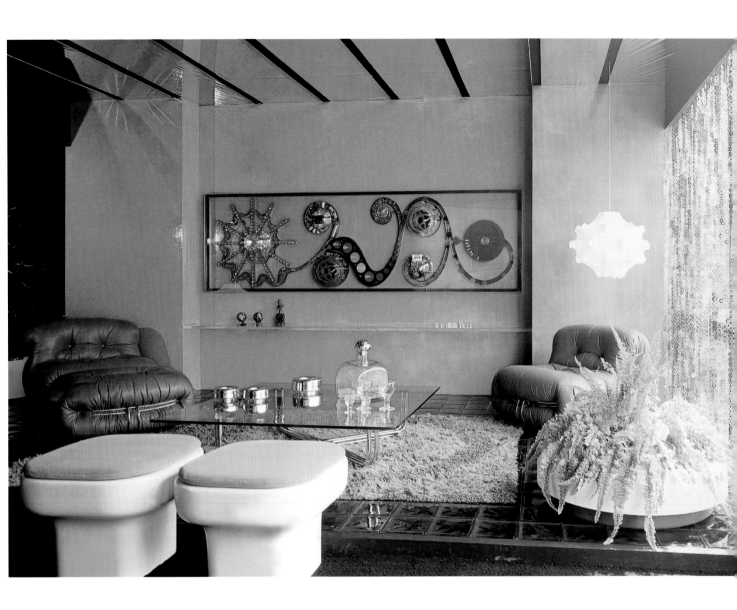

'A room for Peter Sculthorpe', Marion Hall Best, 1971. This setting, with its bright, glazed wall and ceiling finishes and contemporary Italian furniture, was designed for a Society of Interior Designers exhibition in Sydney.

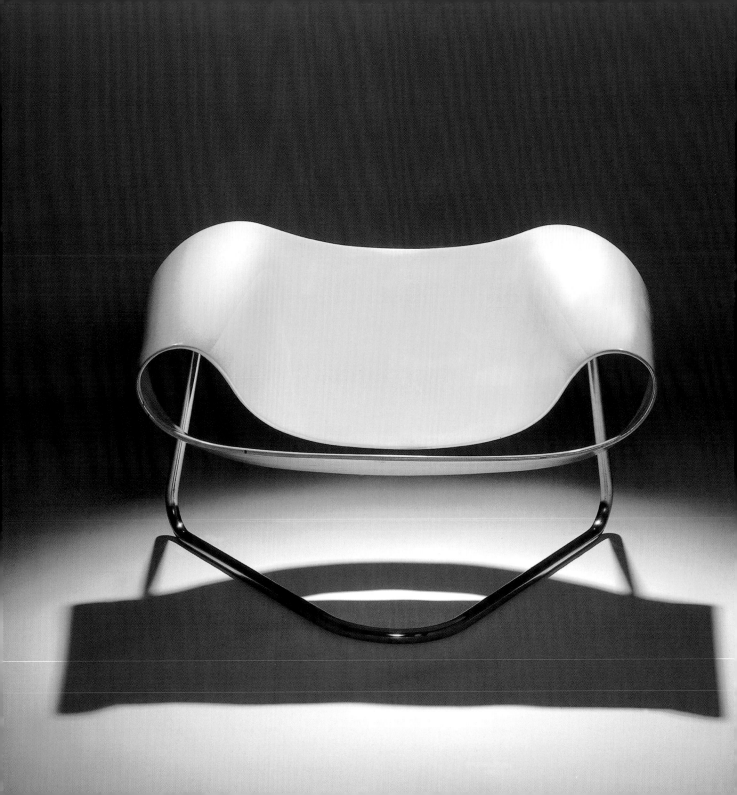

Cesare Leonardi (born Italy 1935) studied architecture at the University of Florence to 1960 and opened his own office in Modena in 1961. In 1962 **Franca Stagi** (born Italy 1937), recently graduated in architecture from the Milan Polytechnic, became a partner in the firm. Specialising in architecture, urban planning and industrial design, the two created a number of furniture designs during the 60s including the novel 'Dondola' rocking chair of 1967 and the elegant 'Ribbon' chair the following year.

Both chairs, featured in the Italian design journal *Domus* in March 1969, exploited the bendable qualities of glass-reinforced polyester to the limit. 'Dondola', produced by the plastics company Elco, was made from one continuous 's'-shaped strip of fibreglass, its underside ribbed to give strength and 'spring'. The epitome of 60s ingenuity, this radical abstraction of a chair has long been enshrined as a classic symbol of this creative decade. The 'Ribbon' chair, produced by Fiarm, is more conventionally supported on a cantilevered tubular steel framework. However its undulating, ribbon-like seat and back, formed from a continuous curve of brightly coloured fibreglass, is unmistakably 60s and echoes the shape of Pierre Paulin's latex foam 'Ribbon' chair of 1966.

Leonardi and Stagi's 60s furniture provides a classic paradigm of the highly successful collaboration between inventive designers and adventurous manufacturers in postwar Italy, a mix that resulted in designs so innovative that their modernity is still admired over three decades later.

Left
Franca Stagi, seated in the 'Ribbon' chair, and Cesare Leonardi in their studio in 1970. In the foreground is their one-piece 'Kappa' stacking table, produced by Fiarm in fiberglass-reinforced polyester. The photo appeared in *Domus* February 1970.

Opposite
'Ribbon' chair by Cesare Leonardi & Franca Stagi, Italy, 1968. Made by Fiarm, Italy, about 1968.

Fibreglass-reinforced polyester, steel,
64 x 91 x 74 cm. 85/1973.

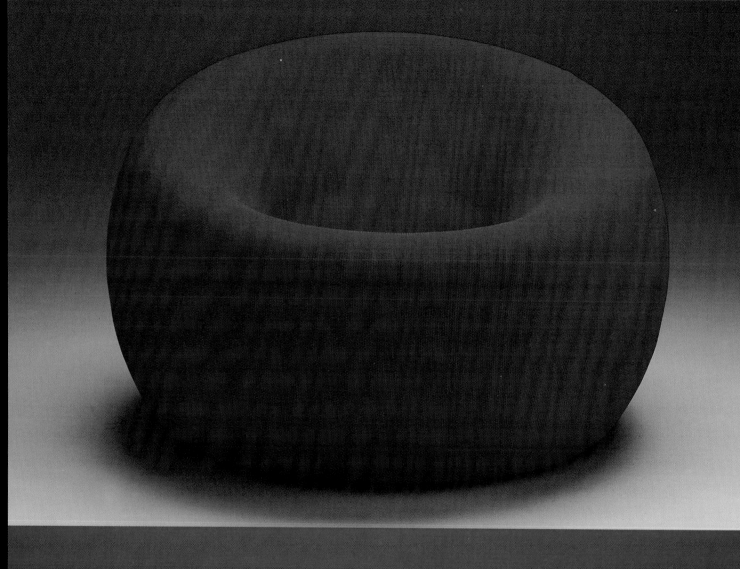

Above
**'UP 1' chair by Gaetano Pesce, Italy,
1969. Made by C&B Italia, Italy, about 1969.**
Polyurethane foam, synthetic fabric, 68 x 90 x 95 cm. 85/115

Opposite
**An advertising image for the six chairs in the
'UP' series, about 1970.**

Architect, designer, sculptor, artist and intellectual, **Gaetano Pesce** (born La Spezia, Italy, 1939) occupies a unique place in postwar Italian design. While an architecture student at the University of Venice, he became involved in experimental art, exhibiting multi-media constructions and installations and participating in the activities of a number of avant-garde European art groups.

In the mid 1960s Pesce began to design with plastics, working with the progressive Italian company C&B Italia (later B&B Italia) to produce the now iconic 'UP' seating series in 1969. This innovative group of six softly curving polyurethane foam shapes, re-released in 2000 by B&B, extended the possibilities of the new medium to its absolute limit; compressed and vacuum packed in PVC packaging the chairs swelled when unsealed, magically transforming into fully formed seating. The seventh and emphatically last piece in the series took the form of a giant polyurethane foot! Pesce was interested in art that established a dialogue between artist and spectator or social group, and in the 'UP' series he invited such a dialogue by seemingly involving the user in the very act of the object's 'creation' — the transformation from non-descript package to functional product.

During the early 1970s Pesce aligned himself with the aesthetic and social theories of the radical 'anti-design' groups in Europe, creating schemes for buildings and objects that expressed his personal views about design's need to constantly explore the nature of its relevance to contemporary society. In 1972 he contributed an installation titled 'City for an age of great contaminations' to the landmark exhibition *Italy: the new domestic landscape* at the Museum of Modern Art, New York. This somewhat apocalyptic 'design as art' commentary on the future repercussions of society's alienation from its environment was echoed in his strange 'Golgotha' suite of polyester-resin furniture of 1972-73.

Pesce's experimentation with the variable qualities and expressive potential of modern synthetics in this suite was elaborated throughout the 70s, 80s and 90s in a number of designs for furniture and lighting whose irregular shapes and rough finish were a deliberate comment on the soul-less, slick homogeneity and standardisation of mass-produced products.

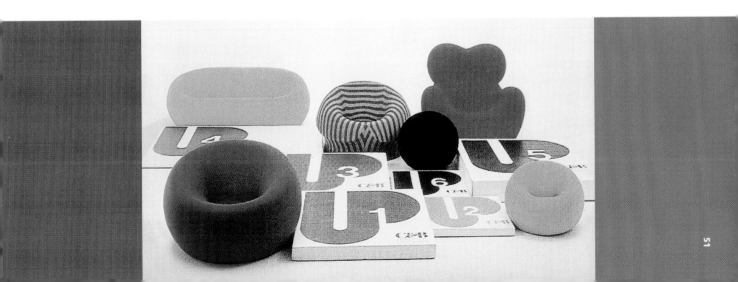

Above

'Sunset in New York' by Gaetano Pesce, Italy, 1980. Made by Cassina, Italy, early 1980s.

Polyurethane foam, wood, Dacron, 120 x 240 x 110 cm.
85/1826

Opposite

Gaetano Pesce, 'Tramonto a New York' (sunset in New York), 1980.

Coloured pencil and pastel on paper, 149.6 x 72 cm.

Despite his independent aesthetic and the limited market for his designs, Pesce has had fruitful collaborations with a number of furniture manufacturers throughout his career, including B&B Italia, Vitra and, most notably, Cassina. In 1980 this adventurous Italian company produced Pesce's 'Sunset in New York', a sofa configured from foam cushions upholstered to suggest the Manhattan skyline. The most overtly 'associational' example of Pesce's furniture designs — he had lived in New York in the 70s — the sofa's apparently pop art references were in fact a comment on the great metropolis's possible decline:

> *Some time ago, we were in New York and I found that this powerful city had grown less stimulating; I was less impressed. I asked myself whether New York was not entering a phase of decadence like that experienced by other cities* ...[22]

Throughout the 1980s Pesce continued to explore the unpredictable properties of plastics (the 'Pratt' chairs, 1983), extended his creative collaboration with Cassina ('Feltri' chair, 1987) and took part in several architectural competitions, most notably one for the redevelopment of Parc de la Villette in Paris in 1982. In the 90s his drive to redefine the boundaries between art and design was undiminished, as evidenced in a series of playful polyurethane resin objects for the New York-based Fish Design, and in 1996 he was honoured with a retrospective at the Pompidou Centre, Paris. Pesce's constant challenging of received orthodoxies, his experimentation with new materials and technologies and his celebration of uncertainty, humour and fragmentation, has, in recent years, brought his unique contribution to late 20th-century design and architecture into sharper focus.

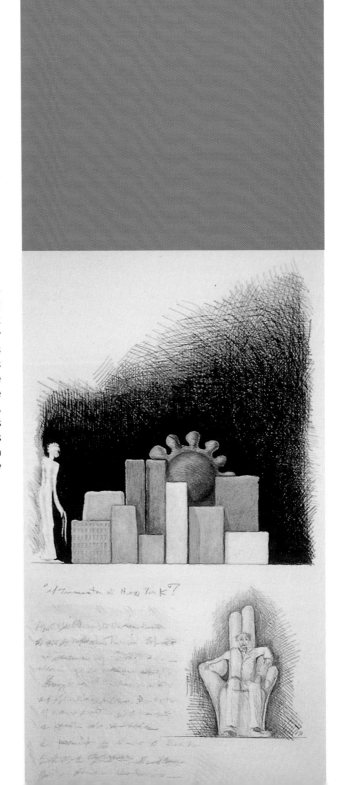

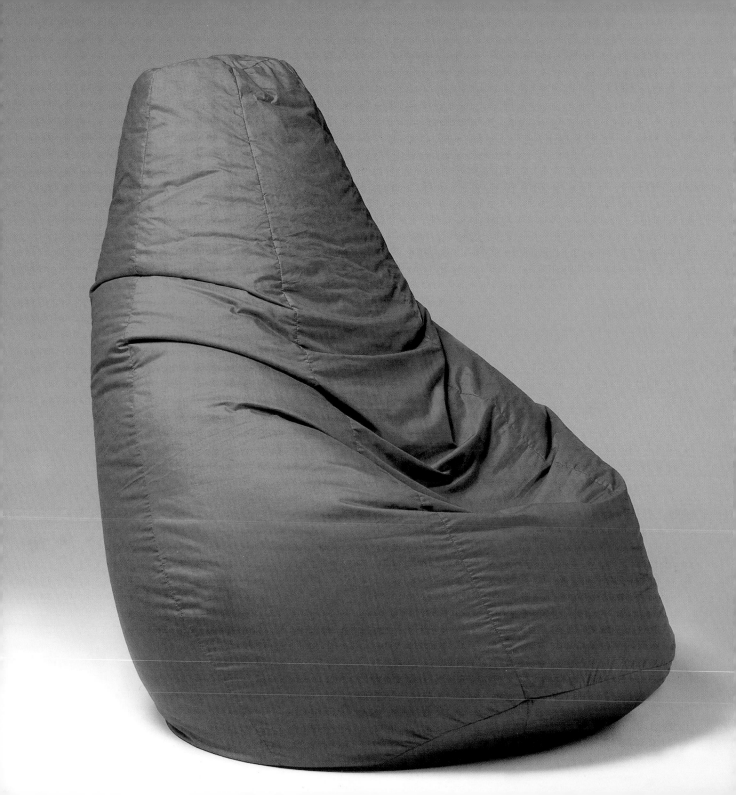

The team **Piero Gatti** (born Italy 1940), **Cesare Paolini** (born Italy 1937) and **Franco Teodoro** (born Italy 1939) established a studio in Turin in 1965, collaborating on architectural, graphic and industrial design projects which challenged the conventional and sought to expand design's traditional boundaries.

Their most significant and enduring design was, without doubt, the 'Sacco' chair, produced by Zanotta from 1969. Simply a shaped leather or fabric bag, without internal framework and filled with thousands of polystyrene bubbles, the 'Sacco' was relatively cheap, easily portable and, in the spirit of the times, eminently suited to being 'laid back' on. So successful was its design that a multitude of versions covered in fabric or vinyl — the familiar 'beanbag' — have been in use ever since. Ironically, although its formlessness was originally conceived as a radical 'anti-design' gesture, the 'Sacco', or more precisely its many variants, has passed into widespread mainstream furniture consumption. Indeed, it was one of the few examples of 'anti-design' furniture to ever be mass-produced in any quantity.

Conceived in a climate of protest and revolt, the beanbag has been a 20th-century design success story. Today, at the beginning of a new century, it is enjoying renewed popularity, once again in bright colours — or in fetching animal prints!

Opposite
'Sacco' by Piero Gatti, Cesare Paolini, Franco Teodora, Italy, 1968. This example was made by Zanotta, Italy, in the mid 1980s.
Telafitta (cotton/nylon), polystyrene, 93 x 75 x 70 cm. 87/809

Right
'Sacco', as shown in *Domus* March 1969, had the novel and highly desirable advantage of being able to accommodate its user in a multitude of casual positions.

Studio 65, established by five architecture and art students in Turin in 1965, was one of a number of Italian design collaboratives formed in the climate of experimentation and change during the 60s and early 70s. Its best-known design is the 1970 'Marilyn', a crimson fabric-covered, lip-shaped polyurethane foam sofa inspired by screen icon Marilyn Monroe. Ironically, while created as a gesture of rebellion against mainstream design, 'Marilyn' looks engagingly seductive and benign today. Studio 65, like many of its contemporaries who turned to the inspiration of popular culture, succeeded in producing a design that, while unorthodox at the time, now appeals by virtue of its clever novelty. Perhaps 'Marilyn' was created as a complement to 'Joe', a 1970 leather-covered, baseball mitt-shaped armchair named after Monroe's first husband, baseball star Joe DiMaggio. 'Marilyn' is also said to have been inspired by Salvador Dali's surrealist 'Mae West' sofa of 1936.

Other work by Studio 65 in the early 70s drew graphically on the inspiration of 'classical' rather than popular culture. The group's 1971 'Capitello', a polyurethane foam chair in the form of an angled ionic capital, and 'Attica' (1972), in the shape of a truncated, fluted Greek column, were obvious and ironic references to classical architecture, long the standard source of inspiration for mainstream western architecture. And on a similar classical theme, Studio 65 designed a semi-circular sofa formed from an arrangement of giant ionic capital volutes for the fourth Eurodomus exhibition in Turin in 1972. These 'tongue-in-cheek', parodic references to Greek classicism anticipated much that was central to the post-modern design language in the 1980s.

Studio 65's adventurous designs in the early 70s were produced by Gufram, a progressive company that worked creatively with a number of designers at the time, producing some extraordinarily imaginative 'furniture' in versatile polyurethane foam or foam rubber. These included the 1967 rock look-a-like 'I sassi' (stones) by Piero Gilardi of Studio 65, and the curiously non-functional 'Il pratone' (meadow) by Gruppo Strum, a bright green polyurethane soft sculpture resembling giant blades of grass.

'Marilyn' sofa by Studio 65, Italy, 1970.
Made by Gufram, Italy, about 1972.
Polyurethane foam, stretch nylon fabric, 83 x 310 x 86 cm. 85/83

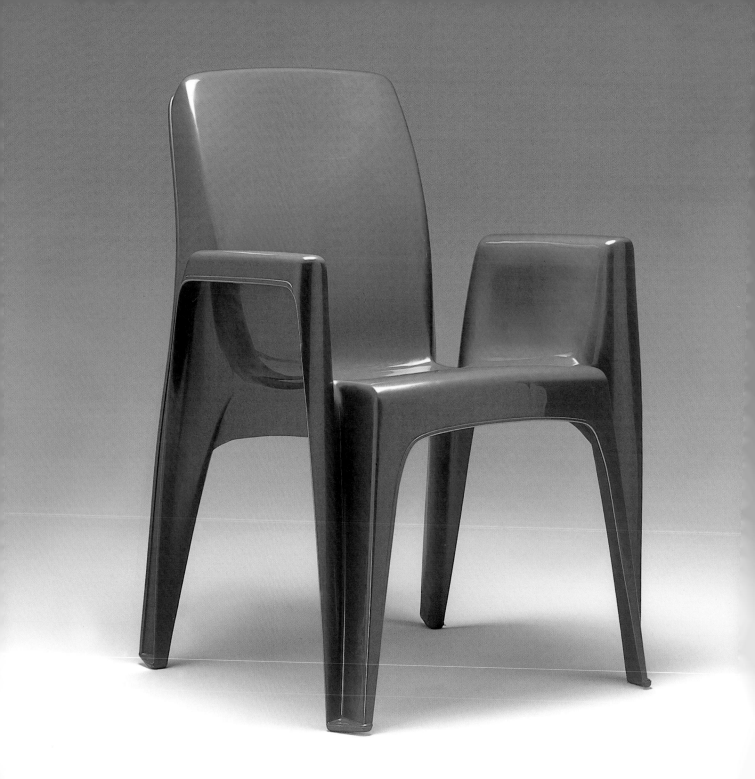

Opposite
'Integra' chair by Charles Furey, Australia,
1969-72, for Sebel Furniture from 1973.
This example is from the mid 1980s.
Polypropylene, 83 x 53 x 57 cm. 86/842

Right
The 'Integra' chair in production at the
Sebel factory, Sydney, mid 1970s.

The **Sebel Furniture** manufacturing company was founded in Sydney in the early 1950s by Harry Sebel, recently arrived from England and with a background in the design and manufacture of metal goods. Sebel's first successful products, such as the 'Stak-a-bye' and 'Fold-a-bye' furniture ranges, were in steel but by the early 1960s the company began working with plastics, producing the 'Tempo' chair with a blow-moulded polypropylene seat and backrest in 1962.

From the mid 60s Sebel commissioned the Australian industrial designer Charles Furey (born 1917 Australia) to design a number of its plastic seating products. Senior designer for the glass packaging company ACI Ltd from 1957 to 1963 and with an impressive record of working with industry, Furey designed the polypropylene-shell 'Furey' range and then the versatile 'Hobnob' series in the early 1970s. Sebel, by now a household name, had become one of Australia's leading producers of contract and public seating.

However Sebel's greatest success story, without doubt, has been its 'Integra' range of chairs. Providing Charles Furey with a brief in 1969 to design a one-piece, injection-moulded plastic chair, Sebel launched the 'Integra' side chair in 1973 and the 'Integra' linkable armchair in 1976. While the first Integras were made of ABS plastic, by 1975 modifications to the dies enabled production in the cheaper, lighter and more supple polypropylene. Reputed to be the first one-piece, stackable, moulded polypropylene chair in the world,

'Integra' met all the requirements of the modern, mass-produced chair — lightweight, efficient to produce (30 chairs can be made by one person in 90 minutes), stackable (up to 15 at a time), versatile, comfortable and highly colourful. 'Integra' was widely exported and despite a market flooded with cheap, plastic imports is still a popular product today. Over one million Integras (in functional grey) have been sold to US Prisons in the last 15 years.

At a time when Australia's plastics industry lagged behind those of most other developed countries, Sebel, under the leadership of the entrepreneurial Harry Sebel, played a pioneering role in utilising the latest available technologies in the production of high-quality goods for a local market. Speaking at a seminar organised by the Plastics Institute of Australia in 1976, Harry Sebel prophetically remarked:

> … *I do believe my company's experience is a case history of a successful melding of the furniture industry with plastic technology … we want to do more and more of this. Because we are convinced that this is the way we have to go.*[23]

Harry Sebel, also well-known as the owner of Sydney's Sebel Townhouse, a recently demolished hotel popular with visiting entertainment industry celebrities in the 60s and 70s, left Sebel in 1982 to pursue a consultancy practice, but the company continues today as a leading manufacturer of seating products.

Florence Broadhurst (born Mungy Station, near Mt Perry, Queensland, Australia, 1899; died Sydney, 1977), experienced a life as seemingly rich and exotic as the wallpapers for which she won renown in the 1960s and 70s. An enigmatic figure in Australian design history, Broadhurst's biographical details prior to establishing her studio in Sydney in 1959 are sketchy and intriguing. Surviving photographs and press clippings reveal that she travelled extensively as a stage artist in Asia during the early 1920s, even establishing her own performing arts academy in Shanghai. In 1927 she moved to London where she married her first husband Percy Kahn with whom she became co-director of Pellier Ltd, a fashionable women's dress salon at 65 New Bond Street, Mayfair, during the early 1930s.

In 1949 Broadhurst returned to Australia with her second husband, Leonard Lloyd Lewis, and their son Robert. During the 1950s she travelled extensively, painting and exhibiting Australian landscapes and eventually settling in Sydney, where she established Australian (Hand Printed) Wallpapers Pty Ltd (later known as Florence Broadhurst Wallpapers Pty Ltd) in 1959. From this year until her still-unsolved murder in October 1977, Broadhurst produced

Opposite
Florence Broadhurst with her wallpapers and fabric samples, Sydney, 1970.

Below and following pages
Wallpaper samples from sample books used by Florence Broadhurst, Sydney, Australia, about 1967–73. Screenprinted by Florence Broadhurst Wallpapers, Sydney.

Paper, approx 49 x 35 cm. 97/322-1

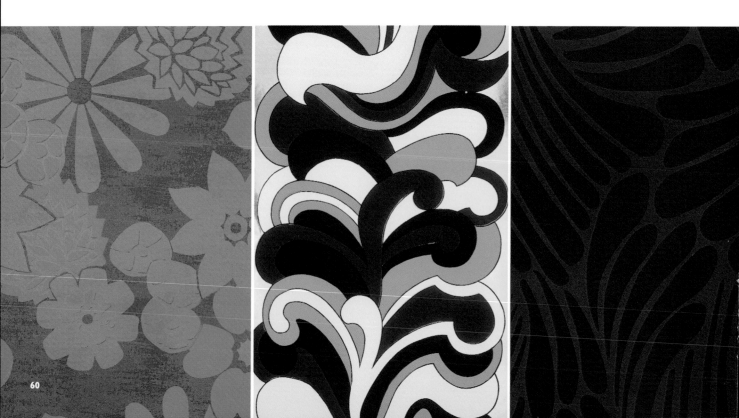

at least 800 designs for wallpapers using more than 80 different colours, most of which are documented in a collection of sample books acquired by the Powerhouse Museum in 1997. These screen-printed designs, including florals, abstracts, textile patterns and animal prints, reflect an eclectic mix of influences and an astute awareness of overseas trends. Broadhurst drew on sources as diverse as the art nouveau and art deco styles, Japanese design, paisley and tapestry patterns and the op art geometry fashionable in the 60s to create a rich range of wallpapers suitable for the needs of her equally diverse clientele. These clients, with whom she dealt on a personal level, included Estée Lauder, Qantas, a chain of Saudi Arabian hotels, Sydney's 'social set' and restaurants and clubs in the Sydney area.

However, just as remarkable and distinctive as her bold patterns was Broadhurst's exuberant use of colour. Rich purples, lime green, silver, reds and pinks, often in metallic finishes, reflected perhaps a little of her own eccentricity as well as the adventurous spirit of the 1960s and 70s. With her flamboyant personality and penchant for strong colour and pattern, it is no coincidence that Broadhurst's career, though by then what could only be described as 'mature', flourished at a time when vibrant colour and bold design statements were *de rigueur* for the fashionable interior.

After her death in 1977 Broadhurst's business was run on a limited basis by her son Robert and also by Wilson's Fabrics. It was then bought by Signature Handprints, which continued to market a small range of her designs (as both wallpapers and fabrics) and was instrumental in reviving appreciation of Broadhurst's legacy in recent times. Today her wallpapers are enjoying renewed popularity and her designs are providing an inspirational source for a number of fashion, textile and interior designers and artists.

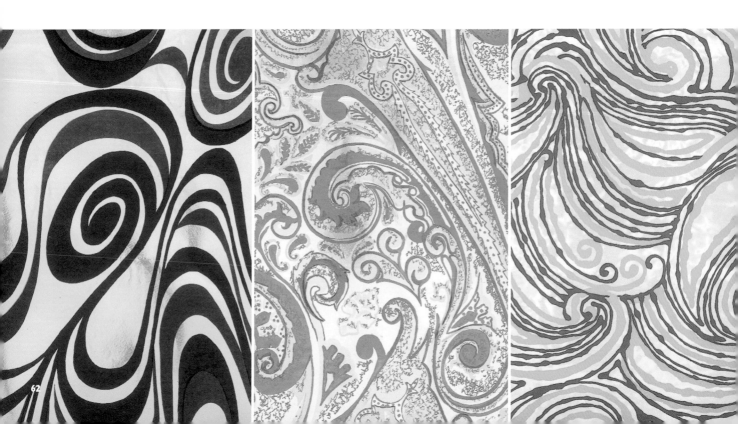

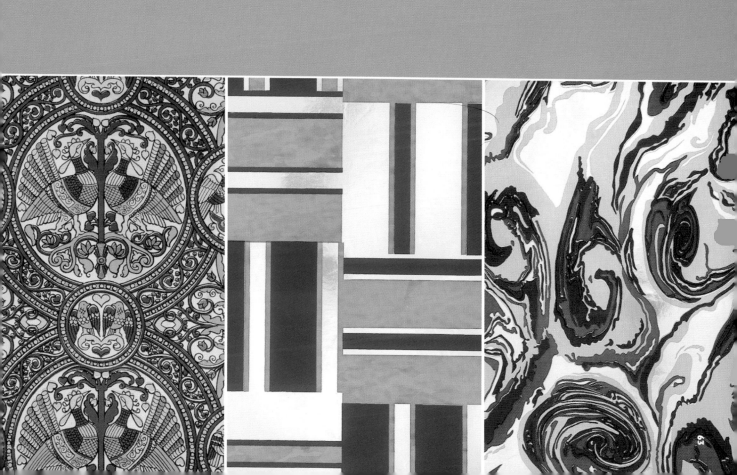

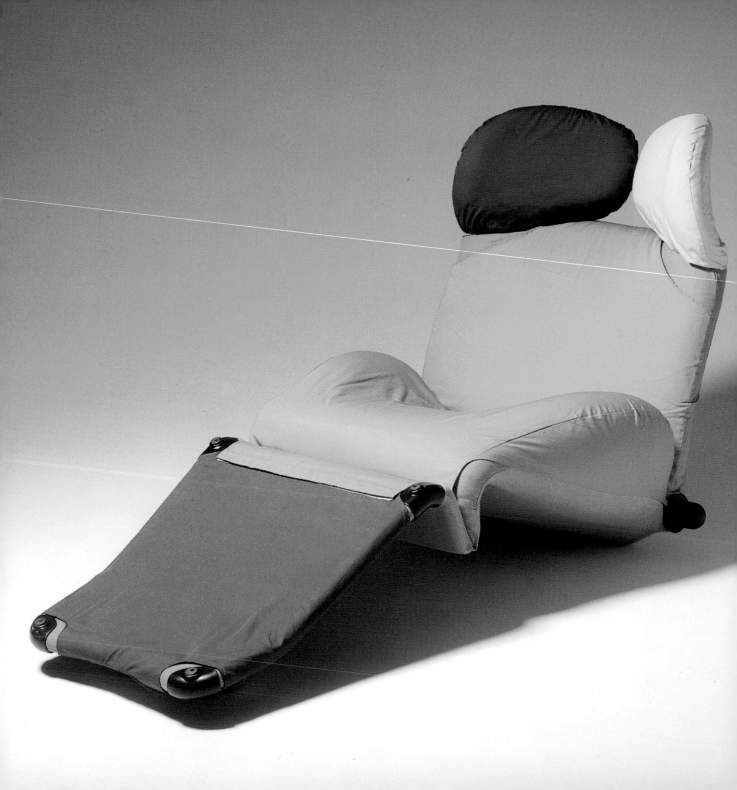

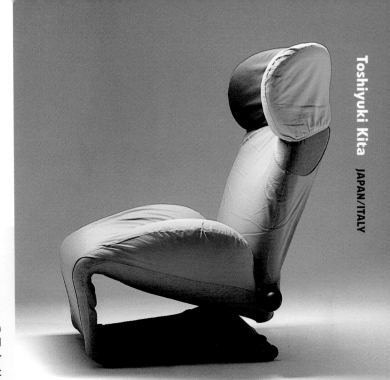

'Wink' armchair/chaise longue by Toshiyuki Kita, Japan/Italy, 1980. Made by Cassina, Italy, from 1980. This example was made about 1984.
Steel, polyurethane foam, Dacron, plastic, cotton fabric, 104 x 84 x 83 cm (armchair). 85/1830

Toshiyuki Kita (born Osaka, Japan, 1942) set up his own design office in Osaka after graduating from Naniwa College of Industrial Design in 1964. In 1969 he began designing furniture for Japanese and Italian companies, an east/west intersection that continued into the 1990s and is reflected in the style of much of his work.

Kita's international reputation was established by his 'Wink' chair of 1980, an ingenious design that took several years of development in collaboration with the manufacturer Cassina before being released at the Milan Furniture Fair in 1981. Composed of three separate units — back, seat and footrest — the chair can be adjusted for use as an upright armchair or reclining chaise. Its 'ear-like' headrests are also adjustable and give the chair a comic quality reminiscent of 60s pop imagery. Launched in Milan at the same time as the Italian design group Memphis hit the scene, 'Wink', like Memphis products, heralded a return to the colour and innovation of the 1960s and a rejection of the safe conservatism prevalent in design since the mid 70s.

In the two decades following 'Wink', Kita has continued to explore the possibilities of different materials, including metal and traditional Japanese materials such as lacquer and paper. His search for an innovative fusion of function and materials, tempered with a little humour — all evident in the 'Wink' chair — has led him down many paths, including tables in partnership with the artist Keith Haring and an elegant, mulberry paper lamp pierced with 91 holes in a thematic nod to the exhibition in which it was shown — *91 objects by 91 designers*, sponsored by Gallery 91, New York, in 1991!

A collective of young designers and architects led by Ettore Sottsass, **Memphis** was formed in Milan early in 1981. Memphis designers shared a common antipathy to current standards of 'good taste' and what they believed was a poverty of creative thinking in contemporary design. Their discontent in many ways evolved from that of the radical Studio Alchimia formed in 1976 around the architects Alessandro Mendini, Andrea Branzi and Sottsass. While Studio Alchimia's avant-garde agenda placed emphasis on the theoretical and the intellectual, Memphis developed its own distinct aesthetic whose consistency was such that it became known as the 'Memphis style'. Memphis products thus provided a bridge across which the group's reformist ideals successfully crossed from designer to consumer.

The name Memphis is said to have derived from the 1966 Bob Dylan record *Stuck inside of Mobile with the Memphis blues again*, played continuously in one of the group's early meetings. Sottsass is credited with suggesting the term because of its contradictory associations with contemporary music, the blues, Tennessee, the birthplace of Elvis Presley, rock 'n' roll, American suburbia and ancient Egypt. Memphis' multiple meanings thus synched with the objectives of the group — to embrace an eclectic range of influences as diverse as, for example, contemporary popular culture, commercial iconography and the rich reservoir of historical references that the modern movement had rejected.

Memphis held its first exhibition in a Milan showroom in September 1981: 'There were thirty-one pieces of furniture, three clocks, ten lamps, eleven ceramics and twenty-five hundred people.'[24] Apart from Ettore Sottsass, those exhibiting work included Michele De Lucchi, Marco Zanini, Matteo Thun, George J Sowden and Nathalie du Pasquier. Although many of the objects were still at prototype stage, several manufacturers had assisted with production and the show received extensive media attention. Memphis' ingredients for the success it was to enjoy over the next few years were already in place — industry support, effective self-promotion and an outrageously daring and colourful aesthetic that flew in the face of 'legitimate' style. Patterned laminates and veneers, unconventional juxtapositions of colours, shapes and materials combined to create objects simultaneously fresh and strange. Memphis objects were as bold, eclectic and unpredictable as the popular culture with which they sought to reconnect.

Over the next three years Memphis became an international sensation. Memphis furniture, lighting, tableware, textiles, fashion and accessories filled the pages of design and lifestyle magazines, were acquired for museum collections world wide, adorned the homes of international celebrities and were eagerly bought up by young, style-conscious consumers.

Yet this extraordinary popularity had its down side. By the mid 1980s Memphis had achieved its ideological goal — wide access to popular, rather than elite, markets. But its very entry in to the mainstream spelt its demise. Widespread imitation of Memphis' post-modernist iconography by market-driven manufacturers totally ignored the group's radical, early ideologies. If Memphis was anti-establishment in 1981, by 1987 it was not only acceptable, it and its many imitators were positively ubiquitous. Memphis had had its day but not without delivering a very effective 'kick' to contemporary design.

Opposite
Memphis designers lounging about in Masanori Umeda's 'Tawaraya' ring, 1981. The group shot includes Michele De Lucchi (third from left), Nathalie du Pasquier with George J Sowden (centre) and Ettore Sottsass (far right).

Left and following pages
Detail of 'Letraset' fabric by Ettore Sottsass, Italy, 1983. Made by Rainbow for Memphis, Italy.
Cotton. 86/1022

One of the postwar era's most radical and influential designers, **Ettore Sottsass jnr** (born 1917, Innsbruck, Austria) studied architecture at the Turin Polytechnic in 1934-39 and began his career in Milan in 1945. Sottsass' early practice coincided with a period of regeneration and reconstruction in Italy, particularly in Milan, home of the avant-garde design publication *Domus* and a rapidly expanding manufacturing centre. Sottsass' interests in these early years were already wide-ranging, embracing painting, sculpture, furniture, graphic design and folk art, as well as architecture. His receptivity to the stimulus of many areas of creativity and his sensitivity to social issues were to form the basis of his visionary ideologies throughout his long career.

The period from the mid 1950s to the late 1960s was a golden era for Italian design. Collaboration between many talented designers and progressive manufacturers, experimentation with new forms, materials and technologies, and clever marketing established Italy's place at the vanguard of international design. During these years Sottsass travelled extensively, working for some time in New York and absorbing influences as diverse as America's mass-consumer culture and Indian mysticism. His design work ranged from interiors, to ceramic and metal tablewares, to industrial design and furniture — a mix of disciplines that he continued to pursue throughout his career. An important part of Sottsass' practice from 1958 was his collaboration with the Olivetti company, for whom he designed a computer, typewriters and office systems using the latest technologies to create products that were aesthetically and technically innovative and highly functional.

Opposite
'Carlton' room divider by Ettore Sottsass, Italy, 1981. Made by Memphis, Italy, early 1980s.
Wood, plastic laminate, 196.5 x 190 x 400 cm. 86/1015

Below
Ettore Sottsass, mid 1980s.

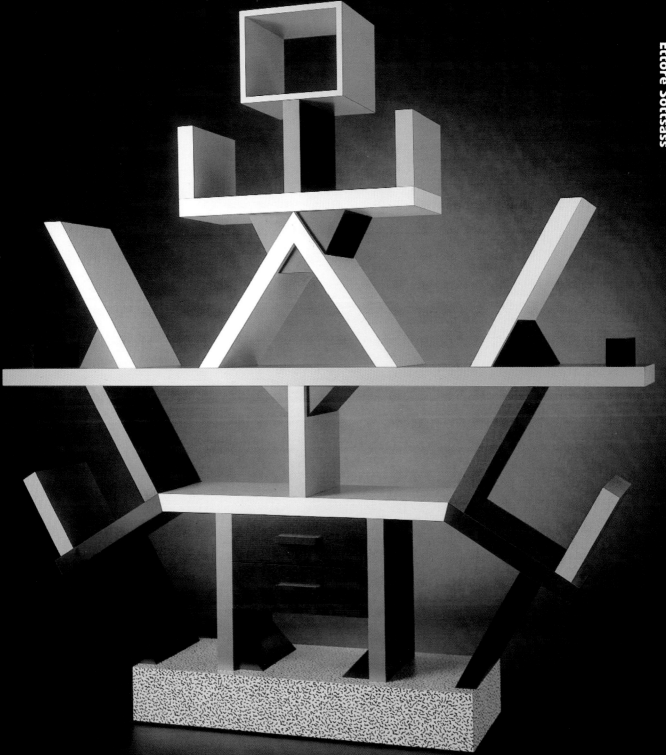

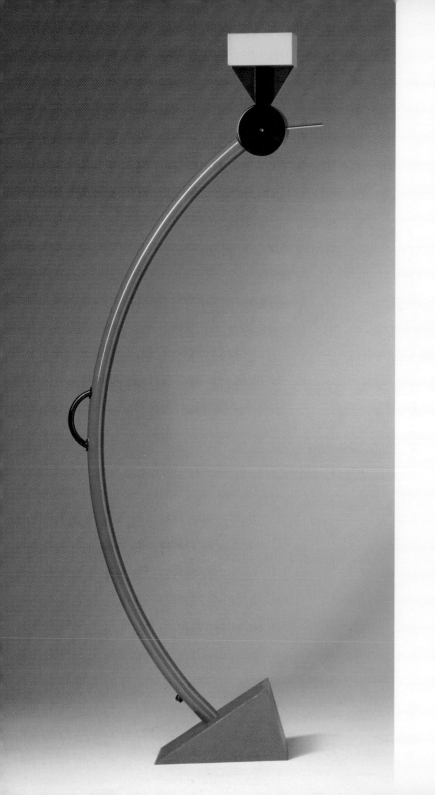

'Treetops' floor lamp by Ettore Sottsass, Italy,
1981. Made by Memphis, Italy, early 1980s.
Metal, halogen bulb, 190 x 25 x 62 cm. 86/1023

In the mid 1960s Sottsass came under the spell of pop art, writing on the subject and designing unconventional furniture that drew on the forms and symbols of popular culture. Towards the end of the decade Sottsass' reaction to what he perceived as design's increasing elitism and isolation from society's real needs led to a more radical theoretical stance and experimental design work:

> *I am searching for ways to help design to acquire basic values, life values, which will assist it to turn out more than just chairs.*[25]

Sottsass became one of the leaders of the 'anti-design' movement of the late 60s and early 70s that sought to reconnect design with contemporary life. Anti-design's rejection of Establishment values was one aspect of the wider social and political protest of the times — the counter-culture's challenge to traditional ortho-doxies. For Sottsass these challenges had a liberating effect, resulting in a period of intense experimentation with a range of influences (kitsch, art deco, mysticism) that provided an escape from the rational grasp of modernism. Strange shapes, unortho-dox colour and non-traditional materials, such as plastic lami-nates, played a vital role in his new aesthetic. During this period Sottsass designed experimental furniture for the landmark 1972 Museum of Modern Art exhibition *Italy: the new domestic land-scape* and created a range of extraordinary vases and totemic sculptures that drew on his interest in ancient cultures.

By the late 1970s Sottsass' international reputation as a designer at the forefront of the avant-garde was well established. Although now in his mid sixties, his continuing questioning of the ethics and aesthetics of design was far from over. Sottsass' designs for the radical group Studio Alchimia at this time were in many ways a rehearsal for the work he was to produce for Memphis. Both the 'Carlton' room divider and the 'Treetops' lamp, designed for Memphis in 1981, synthesise the many influ-ences at play in Sottsass' career — decoration, unorthodox shapes, industrial materials — in an aesthetic that constantly endeavoured to connect design with contemporary society.

In 1980 Sottsass established Sottsass Associati, a partnership of architects and designers which included several of the Memphis designers. Under Sottsass' leadership, the company has continued to practise in a wide range of disciplines — architecture, urban planning, interior, product and furniture design — on an interna-tional basis over the last two decades.

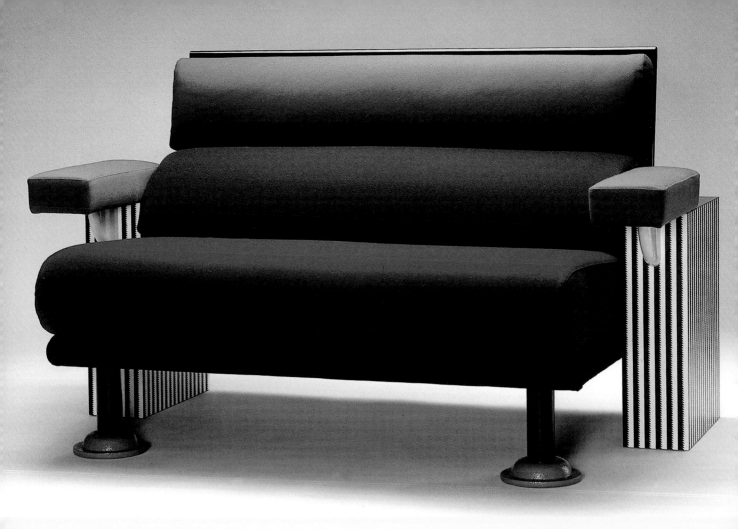

Above
**'Lido' couch by Michele De Lucchi, Italy, 1982.
Made by Memphis, Italy, early 1980s.**

Wood, plastic laminate, polyurethane foam, steel, wool
fabric, 87.5 x 150 x 85 cm. 86/1013

Opposite
**'First' chair by Michele De Lucchi, Italy, 1983.
Made by Memphis, Italy, mid 1980s.**

Metal, wood, 90 x 65 x 40 cm. 86/1014

Michele De Lucchi's (born 1951, Ferrara, Italy) architecture studies in Florence in the early 1970s coincided with the most intense activities of the 'radical' or 'anti-design' movements in Europe. Initiated by a generation of disillusioned youth, this period of worldwide social and political unrest manifested itself in design and architecture as a re-evaluation of the relevance and purpose of contemporary design and an exploration of new ways for design to communicate. In Italy radical groups such as Superstudio and Archizoom developed their own intellectual agendas, published articles and manifestoes, and undertook experimental projects that sought, idealistically, to redefine design so that it could contribute effectively to the creation of a better world.

Stimulated by this provocative environment of debate and experiment, De Lucchi, together with other students in Florence, founded his own radical group, Cavart, in 1973. By 1976 he had established a studio, Architetture e altri Piaceri (architecture and other pleasures), and among his early projects were designs for 'nomadic housing'. These temporary, mobile shelters were intended as an intellectual challenge to the nature of the permanency of more orthodox architecture.

In 1977 De Lucchi moved from Florence to Milan, worked with Andrea Branzi, a former member of Archizoom, and by the following year had begun designing objects for the new design studio Alchimia. This switch from architecture to designing domestic objects created the opportunity for him to develop a new visual language that was to distinguish his work for the next decade. In his new iconography, colour, popular culture, toys, 1950s design and anthropomorphic references combined in objects that broke with the formal constraints of functional modernism.

De Lucchi's work in the stimulating environment of Studio Alchimia brought him into contact with some of Italy's most radical and influential designers, including Alessandro Mendini and Ettore Sottsass. With Sottsass in particular he shared formal and aesthetic ideals and their common interest in popular culture, humour and the everyday merged in the formation of Memphis in 1981. Centred around Sottsass and De Lucchi, the work of the Memphis design collective became the design phenomenon of the 80s and introduced De Lucchi's work to an international audience. De Lucchi designed for Memphis until 1987, his work developing a greater sophistication as Memphis' increasing popularity obviated the need for the 'shock tactics' of its early years. His 'Lido' sofa (1982) and 'First' chair (1983), both identifiably Memphis in their bold colour and unusual form, were mature, developed designs and among the most popular Memphis products.

While still involved in Memphis, De Lucchi designed the highly successful 'Tolomeo' lamp for Artemide (1983), a move towards a more restrained industrial aesthetic that had already been prefigured in designs for Olivetti from the late 70s. In the late 1980s De Lucchi returned to architecture winning the prestigious international competition to redesign the Deutsche Bank branch offices in 1991. In 1990 De Lucchi established Produzione Privata, a collection of luxurious products crafted in limited editions, including vases, lighting and furniture. Throughout the 1990s his Milan-based practice continued to combine product design with architecture, interior design and teaching, for example, at the Domus Academy in Milan and the Cranbrook Academy in Detroit. In 2001 De Lucchi was selected as guest editor for the prestigious *International Design Yearbook*.

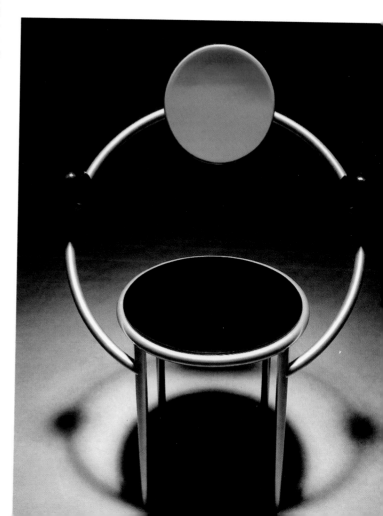

A self-taught artist and textile designer, **Nathalie du Pasquier** (born Bordeaux, France, 1957) has lived and worked in Milan since 1979 and was an original member of Memphis. Introduced to the group by her partner George J Sowden, also a Memphis designer, du Pasquier collaborated on several projects with Sowden and designed the first Memphis fabrics and floor rugs as well as tableware and furniture. The flat patterning of textiles provided a perfect vehicle for the expression of the Memphis aesthetic and du Pasquier's vibrantly coloured, abstract designs, such as the 'Zambia' cotton fabric and 'California' rug of 1982 and 83, were important early agents in establishing the Memphis 'look' and securing its broad, popular appeal. The motifs and colours in her early work for Memphis were strongly influenced by her travels in Africa and India in the mid 70s.

Memphis member and writer Barbara Radice described du Pasquier as:

> ... *a kind of natural decorative genius — anarchic, highly sensitive, wild, abstruse, capable of turning out extraordinary drawings at the frantic pace of a computer ... Her hard, aggressive, acid patterns, her harsh, sharp, flat colours, her broad, black, angular marks make no compromise.*[26]

While still associated with Memphis du Pasquier, with Sowden, also designed a series of screenprinted papers ('Progetto Decorazione'), set up a design office in Milan in 1983 and was involved in architecture, ceramic and textiles projects for a range of companies. Du Pasquier left Memphis in 1987 and since then has concentrated on painting, which she exhibited internationally throughout the 1990s, and ceramic projects including a porcelain cabinet commissioned by Sèvres in 1996.

Above
'California' carpet by Nathalie du Pasquier, Italy, 1983. Made by Elio Palmisano for Memphis, Italy, mid 1980s.

Hand-woven wool, 246 x 191 cm. 86/1019

Right
Nathalie du Pasquier, 2002

Opposite (left to right)

Details of 'Zambia' and 'Cerchio' fabrics by Nathalie du Pasquier, Italy, 1982 and 1983. Made by Rainbow for Memphis, Italy, mid 1980s.

Cotton, 399 x 153 cm. 86/1021; 300 x 140 cm. 86/1020

A resident of Tasmania since 1970, **John Smith** (born England 1948) studied furniture design at the High Wycombe College of Art and Technology before emigrating to Hobart to take up a teaching position at the Tasmanian School of Art. Since 1972 his career has combined practice as a design educator as well as a professional artist, specialising in furniture design but also working on architectural and sculptural projects. Currently he is head of the Centre for Furniture Design at the University of Tasmania.

Smith has participated in numerous solo and group shows locally and internationally, is represented in many public and private collections and has been the recipient of a number of important grants and awards. In 2000 he was selected to participate in the Australia Council's studio residency program in Los Angeles, an experience that has directly influenced his most recent designs. Through his own work and his role as a design educator, he has contributed immeasurably to Tasmania's current standing as an important national and international centre for furniture design and craft practice.

Smith's 1984 'Colourblock' table, its glass top supported by a sculptural configuration of brightly painted wooden geometric shapes, was one of several pieces he produced in the mid 1980s to explore the interplay of pure colour and form. Described in the 1985/86 *International Design Yearbook* — in which they were illustrated — as 'geometric acrobatics … that recall 70s pop',[27] the tables were a direct response to current international efforts to reintroduce colour, form, pattern and a sense of fun to contemporary design, most dramatically embodied in the work of the Memphis group in Italy.

The 'Colourblock' table was shown in a 1985 Crafts Council of New South Wales exhibition *The Bauhaus model*, one of a series of six exhibitions held during 1985 to explore the 'evolution of style'. Writer and designer David Spode's catalogue text neatly sums up the mood of the times:

> *So what of the Bauhaus tradition now? It is still a strong current in contemporary design but only one amongst others … It is more usual now for an artist/craftsperson to find inspiration and evolve a style according to personal interests and preferences. Tradition is there to be studied, learnt from, and inspire, but is does not dictate.* [28]

John Smith's early exploration of the possibilities of 'form, colour and function' to coalesce into a 'sculptural identity'[29] has continued to inform his subsequent work, though the dramatic colour of his mid 1980s designs has been superseded by an emphasis on natural wood surfaces in combination with metal or ceramic detailing. And while the pure, abstract geometry of his earlier work has given way to softer, more lyrical lines, his interest in the sculptural possibilities of furniture — its potential to bridge the divide between function and art — continues to be a major theme in his creative aesthetic.

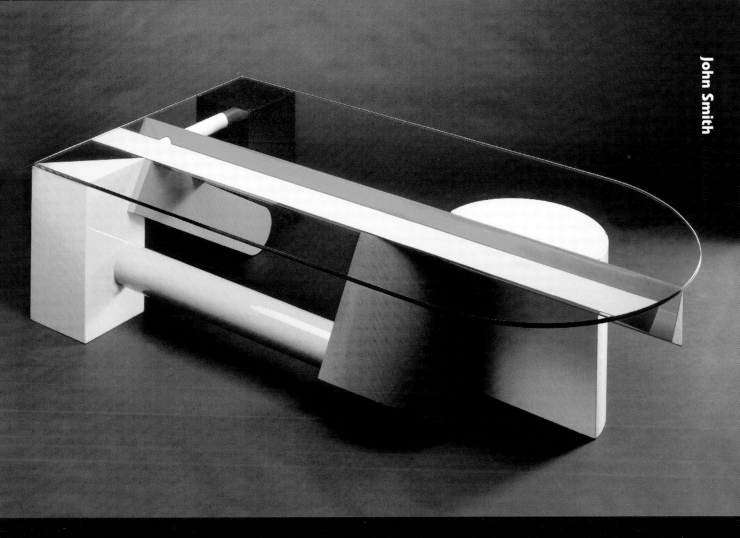

Above

**'Colourblock' coffee table by John Smith,
Australia, 1984.**

Wood, glass, 44 x 180 x 91 cm. 86/120. Gift of the Crafts Board of
the Australia Council & Monahan Dayman Adams, Sydney, 1986.

Opposite

John Smith beside a recent project, Hobart, 2002.

NOTES

1. Katherine B Hiesinger & George H Marcus, *Design since 1945*, Thames & Hudson, London, 1983, p 3.
2. Emily Malino, 'Speaking of colour', *Industrial Design*, April 1967, pp 59-60.
3. Philippe Garner, *Sixties design*, Taschen, Germany, 1996, p 10.
4. David A Hanks & Anne Hoy, *Design for living*, Flammarion, Paris, 2000, p 65.
5. José Manser, 'Free-form furniture', *Design*, December 1968, pp 28 & 31.
6. Barbara Radice, *Memphis*, Thames & Hudson, New York, 1995, p 122.
7. Radice p 4.
8. Radice, pp 25-26.
9. Verner Panton, quoted at www.panton.ch/bio/index.htm
10. Vanni Pasca, *Vico Magistretti*, Thames & Hudson, London, 1991, p 51.
11. Pasca, pp 53 & 55.
12. Marion Hall Best unpublished recollections, 1976, p 62, Marion Hall Best papers, Historic House Trust of New South Wales, Sydney.
13. www.marimekko.fi/
14. Hiesinger & Marcus, p 24.
15. Anon, 'A designer's home is his showcase, too', *New York Times*, 16 December 1970, p 42.
16. Superstudio, 'Invention design and evasion design', *Domus*, June 1969, pp 28-29 insert.
17. 'Gherpe' lamp drawing, dated 24 November 1967, artist unknown, collection Poltronova, Montale Pistoia, Italy.
18. Terence Lane, *Featherston chairs*, exhibition catalogue, National Gallery of Victoria, Melbourne, 1988, p 12.
19. Quoted in Catriona Quinn, *Sydney style: Marion Hall Best, interior designer*, exhibition catalogue, Historic Houses Trust of New South Wales, Sydney, 1993, p 11.
20. Quoted in Quinn, p 29.
21. Gordon Andrews, *Gordon Andrews: a designer's life*, University of New South Wales Press, Sydney, 1993, p 100.
22. Quoted in France Vanlaethem, *Gaetano Pesce: architecture, design, art*, Rizzoli, New York, 1989, pp 75-76.
23. Harry Sebel, 'Furniture from plastics', paper delivered to the Plastics Institute of Australia, Melbourne, June 1976.
24. Radice, p 26.
25. Penny Sparke, *Ettore Sottsass jnr*, Design Council, London, 1982, p 55.
26. Radice, p 88.
27. 1985/86 *International Design Yearbook*, Thames & Hudson, London, 1986, p 49.
28. David Spode, 'The Bauhaus model', exhibition catalogue in the exhibition series *Evolution of style*, Crafts Centre Gallery, Crafts Council of New South Wales, Sydney, 1985.
29. Artist's statement, Hobart, May 1986.

PICTURE CREDITS

Page 4: 'Phantasy landscape' photo courtesy Verner Panton Design, Switzerland; **page 9:** 'Tongue' chair advertisement courtesy Artifort, Netherlands; **page 10:** 'Expo Mark II sound chair' promotion, photo by Dieter Muller, courtesy Mary Featherston, Melbourne; **page 12:** Artes Studios showroom, photo courtesy Dick van Leer, Sydney; Mary Featherston in the 'Obo' chair, photo by Grant Featherston, 1976, courtesy Mary Featherston, Melbourne; **page 13:** chairs in Marion Hall Best's garden, photo by Mary White, 1969, courtesy Historic House Trust of NSW; **page 14:** Gaetano Pesce, photo courtesy Pesce Ltd, New York; **page 19:** Verner Panton, photo courtesy Verner Panton Design, Switzerland; **page 20:** Marianne Panton seated on a 'Panton' chair, photo courtesy Verner Panton Design, Switzerland; **page 21:** prototype of the 'Panton' chair, photo courtesy Verner Panton Design, Switzerland; **page 23:** Vico Magistretti, photo reproduced from *Vanni Pasca, Vico Magistretti*, Thames & Hudson, London, 1991, p 36; **page 25:** Uhra Simberg-Ehrström, photo reproduced courtesy Friends of Finnish Handicraft archives; **page 27:** Marion Hall Best's colonnade, photo by Kerry Dundas, Sydney, courtesy *Vogue Living* magazine, The Condé Nast Publications; **page 28:** Armi Ratia, from Pekka Suhonen & Juhani Pallasmaa (eds), *Phenomenon Marimekko*, Marimekko, 1986, p 91, reproduced courtesy Marimekko; **page 30:** Olivier Mourgue's 'Bouloum' figures, in *Domus*, June 1970, © DOMUS, courtesy Editoriale DOMUS, Italy; **page 33:** Pierre Paulin's 'articulated carpet' in *Domus* July 1968, © DOMUS, courtesy Editoriale DOMUS, Italy; **page 35 and 36:** Eero Aarnio, photos courtesy Adelta, Germany; **page 39:** drawing for the 'Gherpe' lamp, photo courtesy Poltronova, Italy; **page 41:** Mary and Grant Featherston, photo by Adrian Featherston, courtesy Mary Featherston, Melbourne; **page 42:** Marion Hall Best, photo © Australian Consolidated Press, Sydney; **page 43:** 'A room for Mary Quant', photo by Mary White, Mary White Archive, PHM 93/343/1; **page 45:** Gordon Andrews, photo by Mary Andrews; **page 46:** 'Breakfast with Gordon Andrews' setting, photo by David Moore, courtesy Historic Houses Trust of NSW; **page 47:** 'A room for Peter Sculthorpe', photo by Michael Andrews, courtesy Historic Houses Trust of NSW; **page 49:** Franca Stagi, in *Domus* February 1970, © DOMUS, courtesy Editoriale DOMUS, Italy; **page 53:** Pesce drawing, photo by Giles Rivest, Montreal, drawing courtesy Montreal Museum of Fine Arts, Liliane and David M Stewart Collection, anonymous gift by exchange, D93.242.1; **page 55:** 'Sacco', in *Domus* March 1969, © DOMUS, courtesy Editoriale DOMUS, Italy; **page 59:** 'Integra' chair in production, photo courtesy Sebel Furniture Ltd; **page 61:** Florence Broadhurst and wallpapers, photo by Kerry Dundas, courtesy Max Dupain & Associates, Sydney; **page 66:** Memphis designers, photo by Studio Azzurro, reproduced courtesy MEMPHIS SRL: Gruppo Memphis nel 1981 — Tawaraya Ring — Masanori Umeda; **page 68:** Ettore Sottsass, photographer unknown; **page 75:** Nathalie du Pasquier, photograph by Alice Fiorilli, courtesy Nathalie du Pasquier; **page 76:** John Smith, photo by Penny Smith, courtesy Penny and John Smith.

BIBLIOGRAPHY

Ambasz, Emilio (ed). *Italy: the new domestic landscape*, Museum of Modern Art, New York, 1972.

Andrews, Gordon. *Gordon Andrews: a designer's life*, New South Wales University Press, Sydney, 1993.

Anon, 'A designer's home is his showcase too', *New York Times*, 16 December 1970, p 42.

Bogle, Michael. *Design in Australia 1880-1970*, Craftsman House, Sydney, 1998.

Buck, Alex & Vogt, Matthias (eds). *Michele De Lucchi*, Ernst & Sohn, Germany, 1993.

Byars, Mel. *The design encyclopedia*, Laurence King, London, 1994.

De Lucchi, Michele. *The international design yearbook 2001*, Calmann & King, London, 2001.

Eidelberg, Martin. *Design 1935-1965: what modern was*, Harry N Abrams, New York, 1991.

Fiell, Charlotte & Peter. *1000 chairs*, Taschen, Cologne, 1997.

Garner, Philippe. *Sixties design*, Taschen, Cologne, 1996.

Greenberg, Cara. *Op to pop: furniture of the 1960s*, Bullfinch Press, Little, Brown & Co, New York, 1999.

Hanks, David A & Hoy, Anne. *Design for living: furniture and lighting 1950-2000*, Flammarion, Paris, 2000.

Hiesinger, Kathryn B & Marcus, George H (eds). *Design since 1945*, Thames and Hudson, London, 1983.

Horn, Richard. *Memphis: objects, furniture and patterns*, Columbus Books, London, 1986.

Jackson, Lesley. *The sixties: decade of design revolution*, Phaidon, London, 1998.

Kita, Toshiyuki. 'Users, manufacturers and design', *Form, Function, Finland*, no 73, 1999, pp18-21.

Lane, Terence. *Featherston chairs*, National Gallery of Victoria, Melbourne, 1988.

McFadden, David Revere (ed). *Scandinavian modern design 1880-1980*, Harry N Abrams, New York, 1982.

Malino, Emily. 'Speaking of color', *Industrial Design* (US), April 1967, pp 58-61.

Manser, Josè. 'Free-form furniture', *Design* (UK), December, 1968, pp 28-33.

O'Callaghan, Judith. *Gordon Andrews retrospective*, exhibition brochure, Powerhouse Museum, Sydney, 1993.

Pasca, Vanni. *Vico Magistretti*, Thames & Hudson, London, 1991.

Powerhouse Museum. *Decorative arts and design from the Powerhouse Museum*, Powerhouse Publishing, Sydney, 1991.

Quinn, Catriona. *Sydney style: Marion Hall Best, interior designer*, Historic Houses Trust of New South Wales, Sydney, 1993.

Radice, Barbara. *Memphis*, Thames & Hudson, New York, 1995.

Radice, Barbara. *Ettore Sottsass: a critical biography*, Rizzoli, New York, 1993.

Richards, Michaela. *The Best style: Marion Hall Best and Australian interior design 1935-1975*, Art & Australia Books, Sydney, 1993.

Russell, Stewart. 'Florence's renaissance', *World of Interiors*, December 2001, pp 132-137.

Sebel, Harry. 'Furniture from plastics', seminar paper, Plastics Institute of Australia, Melbourne, 29 June 1976.

Siltavuori, Eeva. 'A Finnish cinderella', *Form, Function, Finland*, no 4, 1986, pp 8-16.

Sparke, Penny. *Design in Italy*, Abbeville Press, New York, 1988.

Sparke, Penny. *Ettore Sottsass jnr*, The Design Council, London, 1983.

Sparke, Penny (ed). *The plastics age*, Victoria & Albert Museum, London, 1990.

Suhonen, Pekka & Pallasmaa, Juhani (eds). *Phenomenon Marimekko*, Marimekko, 1986.

Superstudio. 'Invention design and evasion design', *Domus*, June, 1969, about pp 28-33.

Van de Ven, Anne-Marie. 'The only studio of its kind in the world: Florence Broadhurst wallpapers 1959-1977' in *Florence Broadhurst 1899-1977, Parallel Developments*, exhibition brochure, London Printworks Trust, 2001.

Vanlaethem, France. *Gaetano Pesce: architecture, design, art*, Rizzoli, New York, 1989.

Vedrenne, Elisabeth and Fèvre, Anne-Marie. *Pierre Paulin*, Éditions Dis Voir, Paris, 2001.

Victoria & Albert Museum. *Modern chairs 1918-1970*, exhibition catalogue, Whitechapel Art Gallery, London, 1970.

Von Vegesack, Alexander; Dunas, Peter; Schwartz-Clauss, Mathias. *100 masterpieces from the Vitra Design Museum collection*, Vitra Design Museum, Weil am Rhein, 1996.

Von Vegesack, Alexander & Remmele, Mathias (eds). *Verner Panton: the collected works*, Vitra Design Museum, Weil am Rhein, 2000.

Watson, Anne. *Take a seat: chair design in the 20th century*, exhibition brochure, Powerhouse Museum, Sydney, 1989.

ACKNOWLEDGMENTS

A number of people assisted with the research for this book. In particular I would like to thank Bryan Fitzgerald of Chee Soon & Fitzgerald in Sydney; Mary Andrews, wife of the late Gordon Andrews; Deirdre Broughton, Marion Hall Best's daughter; Mary Featherston; Michael Lech, Historic Houses Trust of New South Wales Resource Centre; and Nathalie du Pasquier in Italy.

Of the many Powerhouse Museum staff who contributed specific expertise to the development of the book I am especially grateful to Anne-Marie Van de Ven for access to her research on Florence Broadhurst. I would also like to acknowledge Kathy Hackett for her picture research, Christina Sumner for assisting with information relating to textiles, and photographers Jean-Francois Lanzarone and Marinco Kojdanovski.

ABOUT THE AUTHOR

Anne Watson is a curator of decorative arts and design at the Powerhouse Museum. She has written and lectured widely on many aspects of 19th- and 20th-century design. She is the content editor and contributing author of *Beyond architecture: Marion Mahony and Walter Burley Griffin in America, Australia and India*, Powerhouse Publishing, Sydney, 1998; and contributing author to *Visions of a republic: the work of Lucien Henry*, Powerhouse Publishing, 2000 and *Decorative arts and design from the Powerhouse Museum*, Powerhouse Publishing, Sydney, 1991.

ABOUT THE POWERHOUSE MUSEUM

The Powerhouse Museum in Sydney is Australia's largest and most popular museum. Part of the Museum of Applied Arts and Sciences established in 1880, the Powerhouse Museum was purpose-built in 1988 on the site of a disused power station. Its collection spans decorative arts, design, science, technology and social history, which encompasses Australian and international, and historical and contemporary material culture. The Museum's collection of post war Australian and international furniture is particularly comprehensive, with examples representing major design and technological trends.